BAIN FROID
CHEVRIER

THE "WRITING" OF MODERN LIFE: THE ETCHING REVIVAL
IN FRANCE, BRITAIN, AND THE U.S., 1850–1940

The "Writing"

of Modern Life

THE ETCHING REVIVAL IN FRANCE, BRITAIN, AND THE U.S., 1850–1940

Elizabeth Helsinger with Martha Tedeschi, Anna Arnar,
Allison Morehead, Peyton Skipwith, and Erin Nerstad

SMART MUSEUM OF ART
UNIVERSITY OF CHICAGO

Catalogue published in conjunction with the exhibition
*The "Writing" of Modern Life: The Etching Revival in France,
Britain, and the U.S., 1850–1940*
Smart Museum of Art
University of Chicago
November 18, 2008–April 19, 2009

Design and typesetting: Joan Sommers Design, Chicago
Project Editor: Anne Leonard
Copy Editor: Katherine E. Reilly
Printed in China

Library of Congress Cataloging-in-Publication Data

The "writing" of modern life : the etching revival in France,
Britain, and the U.S., 1850–1940 / Elizabeth Helsinger . . . [et al.].
 p. cm.
 Catalogue published in conjunction with an exhibition held at
the Smart Museum of Art, the University of Chicago, November
18, 2008– April 19, 2009.
 Includes bibliographical references.
 ISBN 978-0-935573-45-9 (alk. paper)
 1. Etching—19th century—Exhibitions. 2. Etching—20th
century—Exhibitions. 3. Etching—Illinois—Chicago—
Exhibitions. I. Helsinger, Elizabeth K., 1943– II. David and Alfred
Smart Museum of Art.
 NE1994.W75 2008
 769.9'034074773311—dc22
 2008023585

The "Writing" of Modern Life is one in a series of projects at the
Smart Museum of Art that has been generously endowed by the
Andrew W. Mellon Foundation. The exhibition catalogue was
made possible by the Feitler Family Fund.

Front cover: Frank Short after Joseph Mallord William Turner,
Ben Arthur, c. 1888 (cat. 36); inset, Armin Landeck, *East River
Drive*, 1941 (cat. 20).

Reverse cover: top, William Strang, *The Mother*, 1884 (cat. 38);
bottom, Julius Komjati, *Morning*, 1919 (cat. 19).

Photography Credits: Photography by Tom Van Eynde unless
otherwise noted; figs. 1, 35, 40, 41, 45, Photographs by Jennifer
Anderson © The Art Institute of Chicago; figs. 3, 6, © The
National Gallery, London; fig. 11, Reproduced courtesy Estate of
Muirhead Bone; figs. 14, 18, 21, 43, 67. University of Chicago
Library, Special Collections Research Center; fig. 16, Photograph
by Robert Lifson © The Art Institute of Chicago; figs. 17, 26, 27, 33,
36, 38, 46, Photographs © The Art Institute of Chicago; fig. 23,
Reproduced courtesy Estate of Armin Landeck; figs. 24, 25,
Reproduced by kind permission of Robert K. Newman; figs. 32, 53,
Images courtesy of the Board of Trustees, National Gallery of Art,
Washington; fig. 37, Minneapolis Institute of Arts; fig. 39,
University of Chicago Library; fig. 48, Photograph by Karin Patzke
© The Art Institute of Chicago; figs. 50, 51, 57, 58, 59, 64, 66, ©
Trustees of the British Museum; figs. 63, 73, 74, Reproduced by
kind permission of Rachel Austin; fig. 65, Estate of Paul Drury.

ISBN: 978-0-935573-45-9

CONTENTS

Preface and Acknowledgments

vii

ELIZABETH HELSINGER

The "Writing" of Modern Life

I

MARTHA TEDESCHI

The New Language of Etching in Nineteenth-Century England

25

ANNA ARNAR

*Seduced by the Etcher's Needle: French Writers and the
Graphic Arts in Nineteenth-Century France*

39

ALLISON MOREHEAD

Interlude: Bracquemond and Buhot

57

PEYTON SKIPWITH

Toward a Gothic Vision

67

ERIN NERSTAD

Postlude: Reflections on Some Impressions

87

Checklist of the Exhibition

97

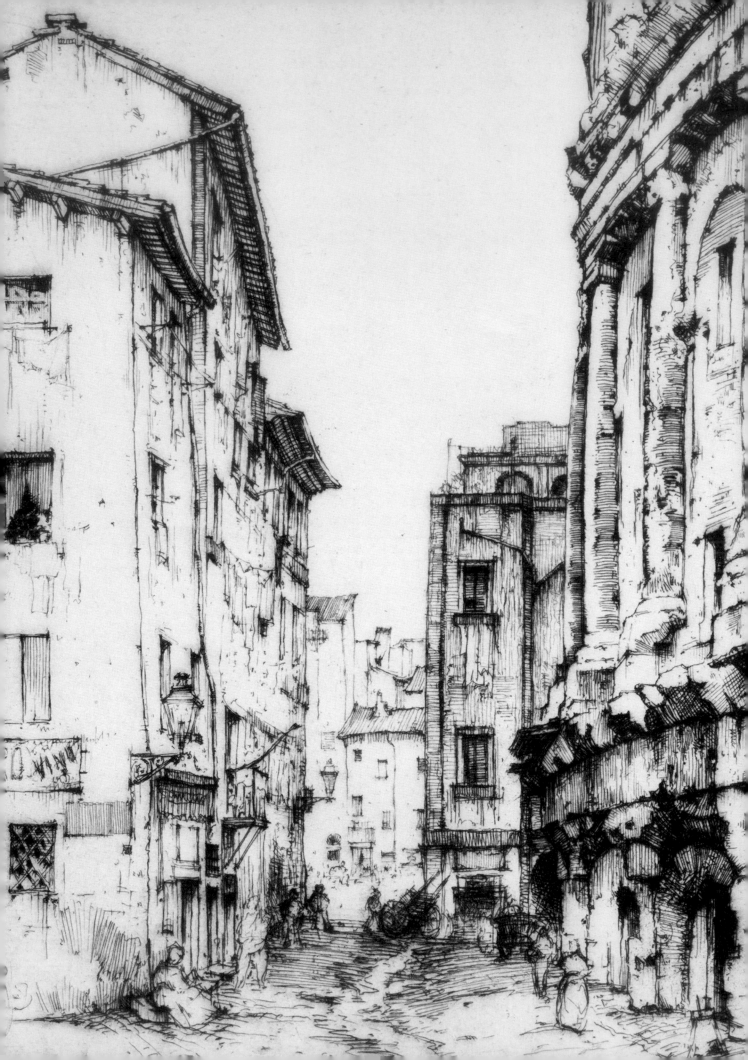

PREFACE AND ACKNOWLEDGMENTS

THE REVIVAL OF ETCHING as a form of original artistic expression around 1850 or so has generally been studied in relation to other visual media. From 1839, photography began to threaten the professional security of printmakers who hitherto had met demand for imagery when multiples were required. Printmakers began to see their livelihood as depending on the aesthetic qualities of their medium, that is, the ways in which impressions of the same image could be made different, not identical.

This catalogue and its accompanying exhibition take an alternative approach, namely, to consider etching as a form of *writing*: not only the ways in which the freedom of the etched line mimicked that of handwriting, with similar "signature" qualities, but also the ways in which the critical language of etching became entwined at this period with literary discourse. Writers and etchers joined forces to promote their respective arts as expressions of the artist's individual personality. Some etchers adopted literary illustration as a vehicle for their work, further cementing the close relationship between etching and writing.

It is perhaps not surprising that the term "etching revival" is often taken as a nod to some imagined lost golden age of etching. Nineteenth-century practitioners such as Haden and Whistler indeed looked back unabashedly to previous masters of the medium, above all to Rembrandt. More remarkable is the fact that etching was found to be suitable for gritty modern themes as well as classic pastoral subjects. Dockworkers, beggars, war dead—all found their place in etchings discussed on the following pages, a testament to the medium's supreme adaptability.

Standard accounts generally focus on the heady early years (the 1850s and 1860s) and the major early players (Bracquemond, Meryon, Haden, Whistler), failing to acknowledge that the "revival" persisted well into the 1920s and 1930s. The broad parameters of the gift that made this exhibition possible argue that the twentieth-century proliferation of etching clubs in Europe and the United States helps to give a fuller idea of the etching revival's true complexity and reach. For this more inclusive view, we are considerably indebted to Joseph V. Smith (1928–2007), a mineralogist who taught at the University of Chicago from 1960 until 2003, and his wife Brenda, who, working with senior curator Richard Born, made a gift of more than two hundred prints over nearly a decade. What animated this couple's collecting was not a fussy concern with proof states or an exclusive focus on coveted artists, but rather a fascination with the limitless expressive possibilities of the medium and an appreciation of its democratic accessibility even to "Sunday etchers." We are extremely grateful and pleased to be able to offer this posthumous tribute to Professor Smith.

No one could have engaged with this area of our collection more thoughtfully or more diligently than our faculty curator, Elizabeth Helsinger, the John Matthews Manly Distinguished Service Professor in the Department of English and the Department of Art History. Bringing to bear a deep understanding of relations between the literary and visual arts, especially in nineteenth-century Britain, Beth tackled the project with ardor and perseverance. From North Carolina, where she held a National Humanities Center fellowship during 2007–08, she marshaled a team of authors and developed the vision of this catalogue. We sincerely thank her for her exceptional dedication.

Thanks are also due the other authors (besides Beth herself) for their richly illuminating contributions to the publication: Anna Arnar (Associate Professor of Art and Design, Minnesota State University Moorhead); Allison Morehead (Research Fellow, King's College, Cambridge University); Erin Nerstad (PhD candidate, Department of English, University of Chicago); Peyton Skipwith (Director Emeritus, The Fine Arts Society); and Martha Tedeschi (Curator in the Department of Prints and Drawings,

Art Institute of Chicago). Kerri Hunt, PhD student in English, worked with Beth and Erin to produce the initial vision of the exhibition, the catalogue, and the accompanying course. Continuing the partnership that has yielded such effective results in previous Mellon Projects, Joan Sommers designed the catalogue and Katie Reilly edited it; we are grateful as ever for their expert hand and sound judgment.

For the loan of books that flesh out the literary context of the exhibition, we thank the Special Collections Research Center of the University of Chicago Library, Alice Schreyer, Director, and Patti Gibbons, Preservation Manager. Julia Gardner, Judith Dartt, and Christine Colburn on the Special Collections staff were of great help with photographs. We thank Emily Vokt at the Art Institute of Chicago for graciously answering many collection queries, and Jolyon Drury for his kind assistance. It is a pleasure also to acknowledge Martha Tedeschi, who, in addition to her catalogue essay, provided valuable information, images, and advice at several key points.

The project could not have been realized without the generous financial support of the Andrew W. Mellon Foundation and the Feitler Family Fund. The continued strength of the Smart Museum's Mellon Program, which encourages the integration of the Museum's collections into the academic and curricular life of the University, is indebted not only to the sustained generosity of the Mellon Foundation but also to the dedicated leadership of Anne Leonard, Curator and Mellon Program Coordinator. She managed the many demands of this complex project with keen intellect, quiet determination, and characteristic poise.

Irene Backus, Graduate Curatorial Intern for Mellon Projects, skillfully managed all the comparative image orders and reproduction permissions. Among the other staff members whose various talents helped bring the project to fruition, we recognize in particular Richard Born, Senior Curator; Natasha Derrickson, Associate Registrar for the Permanent Collection; C. J. Lind, Public Relations and Marketing Manager; Kristy Peterson, Director of Education; Stephanie Smith, Director of Collections and Exhibitions; Angela Steinmetz, Registrar for Loans and Exhibitions; and Karin Victoria, former Director of Development and External Relations.

As the art museum of the University of Chicago with unique access to the resources of a remarkable institution, the Smart Museum views the encouragement and presentation of research on its collections as one of its highest obligations. It is also always an enormous privilege to work closely with gifted members of the faculty, particularly when the results are as satisfying as those documented in this volume.

Anthony Hirschel
Dana Feitler Director

THE "WRITING" OF MODERN LIFE: THE ETCHING REVIVAL
IN FRANCE, BRITAIN, AND THE U.S., 1850–1940

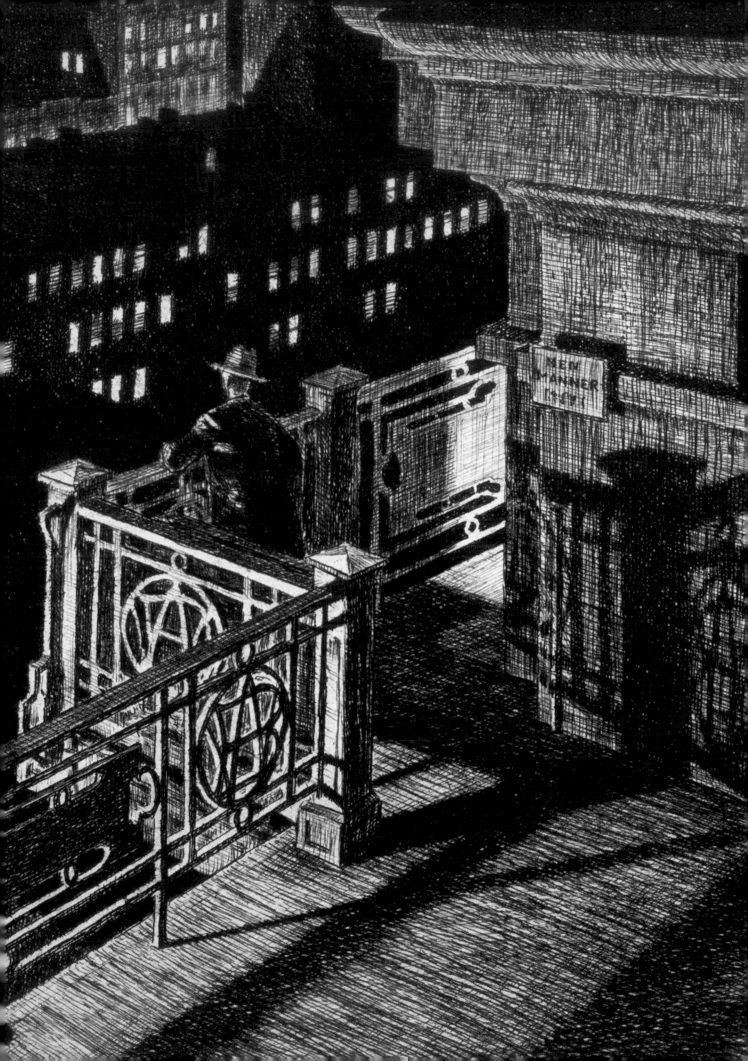

ELIZABETH HELSINGER

The "Writing" of Modern Life

FICTION—FROM BALZAC and Dickens to Dreiser—may be the genre that we look to first to trace the imaginative impact of modernity in the nineteenth and early twentieth centuries. But a strong case can be made that etching briefly played that role in the visual cultures of three countries: France, Britain, and the United States. Like the novel, etching was both old and new; it "revived" an art, or a technical medium, that had never really died, but in doing so, it created a space apart from the subject and genre expectations that burdened contemporary paintings and poems. In that brief period in which photography had not yet come to dominate black-and-white reproductive arts (between the mid-nineteenth century and the close of the 1930s, when the bottom dropped out of the market for etchings and artists turned to other media for survival), etching was reinvented as a popular medium for expressing the experience of modernity. Though primarily representational, etching provided artists and critics a chance to emphasize formal elements (the expressive capacities of line and space and tone) and thus to deflect viewers from the relentless search for realistic detail and hidden stories that much nineteenth-century British and American art encouraged.

This reinvention of etching as modern in a double sense—as a non-narrative, anti-realist art of line and tone evoking the look and feel of modern life—was in no small part the work of publishers, dealers, critics, and artist-advocates who created a market for the original etching, a language for discussing and evaluating it, and a mythology about the painter-etcher and his, or often her, medium. But it was also, of course, the creation of working artists themselves.

Etchers and critics together rediscovered a medium uniquely fitted to express the look and feel of a changed landscape whose human inhabitants often felt less than at home in it. Through the etchings produced so plentifully in this period, one can track a darkening vision. Familiar views of both rural scenery and sublime prospects, or of well-known sites of picturesque travel, take on a new and unsettling visual intensity (John Taylor Arms, Ernest David Roth) or acquire strange shadows, as if revisited in memory yet differently seen (Arms, F. L. M. Griggs; see the essay by Skipwith in this volume). And new, particularly urban and industrial subjects appear: city waterfronts (James McNeill Whistler, James McBey), bridges (Frank Short), railroad yards (Muirhead Bone), tenements (Hablot Browne), the canyons of streets between high buildings (Martin Lewis), industrial fringes (Armin Landeck), the devastation of World War I (Percy Smith, Kerr Eby). Modern subjects are often viewed through angles that distort relationships between the human figure and the newly built or demolished landscape to disquieting effect. Implicitly, such works ask whether human beings can be at home in the alienating places they depict.

Etching foregoes realistic repleteness of detail and color in exchange for an emphasis on line and the empty space around it that allows the artist-etcher to transform a still firmly representational art (and in this sense a conservative one) into an expressive medium. Restricted to black, white, and shades of gray, revival artists reveal sometimes chillingly abstract shapes and patterns in both

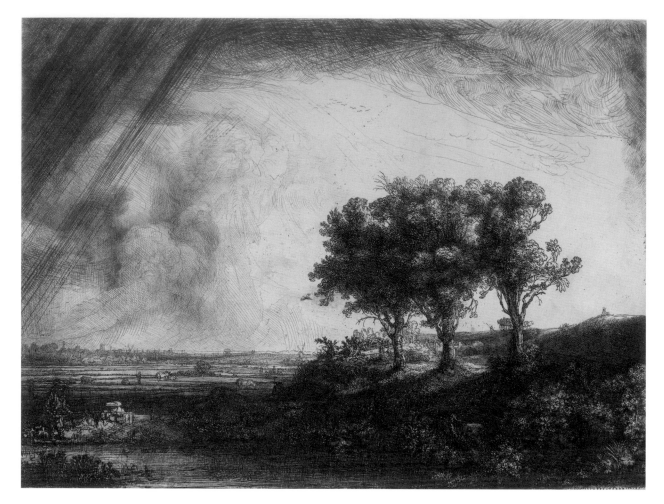

FIGURE 1
Rembrandt van Rijn
The Three Trees, 1643
Etching and drypoint
20.9 x 28.1 cm, plate
The Art Institute of Chicago, Clarence Buckingham Collection, 1938.1811

old landscapes and modern cityscapes. Etched vision can render everyday objects and scenes unfamiliar and disturbing, imbuing them with powerful emotional qualities—unexplained fear, loneliness, and sorrow, the troubling shadows of urban modernity.

Etching was widely promoted as both a demanding expressive medium and a welcoming, democratic one, accessible to artists lacking academic training in art.[1] It was accessible too to people not versed in art history or connoisseurship and without much money to spend: middle- and lower-middle-class viewers of modest means

who had never seriously looked at or collected art before. The etching was praised as an "original" print (despite the apparent contradictions of that term) that mysteriously bore the touch of the artist's hand and the mark of her mind even though it existed in multiple impressions.[2]

For viewers as well as artists, etchings are usually intimate works, small in scale and quiet in their rhetoric. They appear to speak a more private language and address viewers more personally than is possible with paintings, which compete for attention in the crowded, socially competitive spaces of prestigious exhibitions, galleries, and

museums.³ Etchings can be taken home, held in the hand, studied in the privacy of the middle-class parlor or the cramped rented room of the new city worker. They also offer opportunity for the secret passion of the collector. The collection itself, as we have come to understand, can be a medium of expression. "Come up and see my etchings" (the phrase appears to originate in the early twentieth century, at the height of the etching revival) became a cliché as a scarcely veiled invitation to seduction. Looked at more sympathetically, though, it resonates as the popular voice of a specifically modern urban loneliness, an invitation to share the visual passion, emotional intimacy, and disturbing strangeness captured by these unassuming but often eloquent works.

Thus far I've described a relatively coherent rhetoric about the new/old form: its ease, swiftness, spontaneity, accessibility, and aptness as an expressive vehicle, all qualities derived from a definition of etching that strongly identified it with "free," "independent," and thus (for some critics) "masculine" line, used sparingly and suggestively to evoke forms out of the blank white of paper. As Martha Tedeschi describes at greater length in her essay in this volume, critics in Britain initially drew their understanding of etching as an art of line from the work of Seymour Haden and James McNeill Whistler. They looked back through Haden and Whistler to precedents in the etched work of Rembrandt (as a landscapist particularly), which Haden collected. As early as 1868, Philip Hamerton, in the first edition of his influential *Etching and Etchers*, insisted that "the central idea of etching is the free expression of purely artistic thought," to which line is central. "An etched line, when it is good, is always in the highest possible degree suggestive, interpretative, explanatory, but hardly ever imitative. Etching is an art which appeals almost exclusively to the mind."⁴ A. M. Hind, in his *Short History of Engraving and Etching* (1908), praised Haden because he used line "forcibly, but fully … continuing in the lineal method for which Rembrandt's *Three Trees* is a starting point" (Figure 1).⁵ "True etchers," Hamerton insisted, "show the etched line frankly, and rely upon it, and make the most of it, such as Rembrandt, Vandyke, Whistler, and Haden. False etchers … though they may be exquisite artists, do not understand the value of the naked line."⁶ If etching is primarily an art of "the naked line," then etchers who sub-

ordinated line to shadow and depths of tone could not be "true" etchers for Hamerton. Yet these always constituted a major group of artists who used the medium and hence a difficulty for the unified rhetoric of revival critics. I shall return to this alternative view of etching as an art of intricacy and darkness, whose gothic possibilities are explored at greater length in Peyton Skipwith's essay.

The importance of line in the work of Haden and Whistler, according to critics, was closely interwoven with the function of the surrounding blank page. Hind observed with approval that Whistler, even in his early work, was "already mastering the art of omission. … No etcher has ever known better than Whistler what can be achieved by the unfilled space."⁷ The key notes of British criticism were not only freedom of line but concentration, selection, and omission. Knowing what to leave out was as important—and as difficult—as knowing what to put in. A minimum of freely drawn lines evoked a space of varied light and movement palpably surrounding the forms and planes of the modern city and its adjacent countryside. Every line of a master etcher must guide a viewer to complete the image, evoking from means that represented nothing in themselves (mere "notes of strange concurrences of line")⁸ a city skyline or a crowded harbor, bathed in an atmosphere of light.

Hind found Whistler's visual purism—the abstraction of his attitude toward line and page—curiously cold. Despite "a luminosity of tone and a quality of surface which are unequalled," he lacked "the peculiar force of Rembrandt which fixes the attention to one predominant emotional element. His genius had little to do with humanity."⁹ But others recognized in that curious coldness a distinctly modern response. For French poet-critic Charles Baudelaire, etching caught the alienating strangeness of the transformed city; he praised particularly the Parisian etchings of Charles Meryon and the Thames views of Whistler. To Baudelaire this work conveyed a powerfully resonant vision precisely because it was devoid of the emotions viewers expected art to offer, warming tears of sympathetic love or sorrow. It was not that the etching was inexpressive; indeed, Baudelaire wrote, "it would be difficult for the artist not to describe on the plate his most intimate personality."¹⁰ The etched line is as uniquely individualizing a gesture as the signing of one's name or the

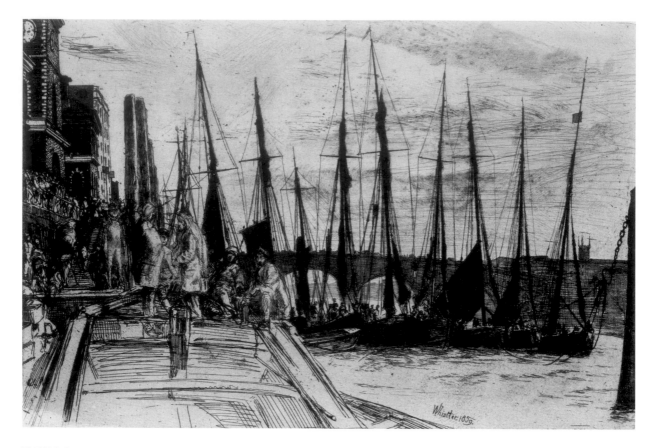

FIGURE 2
J. A. M. Whistler
Billingsgate, 1859
Etching
Cat. 41

writing of a lyric poem. Etching, Baudelaire implies, gives physical form to lyric thought: the artist utters his lonely individuality and thus indirectly speaks to other isolated souls, alone together in the city. It is a curiously asentimental but intimate art. Etching thus appears as at once purely visual—strange concurrences of line—and the most literary of the visual arts.[11]

Work from Whistler's *Thames Set* (published 1871, executed between 1859 and 1870) and from his later Venetian series can illustrate this vision of the etcher as modern poet. His now-famous but once startling views of London's wharves and dockyards display the masterful economy of his lines, but they also show the unsettling potential of his refusal of narrative or sentiment, his failure to establish conventional distance between laboring figures and the viewer, and his apparent disregard of realist spatial coherence. *Billingsgate* (Figure 2) is not easy to read. Jutting out toward the viewer in the left foreground is a minimally sketched, evidently unstable boat, our only entry to this contemporary view of a working urban waterfront. At the far end of the boat, barring our way, is a more fully drawn group of fishermen, talking together or gazing out at the viewer. As Emma Chambers notes, Whistler's laborers do not labor: at rest, they look back, confronting the touristic visitor.[12] Beyond this group, in much greater definition, steep stairs on the far left ascend to the grand buildings of London. It is as if the image were coming into focus with the move back and up toward the city. Behind this part of the picture glimmers a memory of some classical harbor scene, perhaps Claude Lorrain's *Seaport with the Embarkation of the Queen of Sheba* (Figure 3), hanging in the National Gallery not far

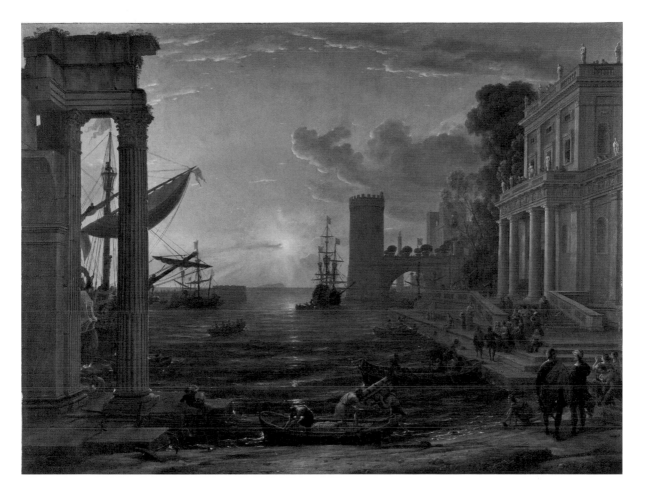

FIGURE 3
Claude Lorrain
Seaport with the Embarkation of the Queen of Sheba, 1648
Oil on canvas
149.1 x 196.7 cm
NG14, Bought, 1824
© The National Gallery, London

away—though the distorting low perspective from which the steeply rising buildings are seen suggests the gothic imagination of a Piranesi, the great seventeenth-century etcher of Roman ruins and architectural fantasies. That half-remembered image of classical stability jars uncomfortably with the rocking boat and idle men, and clashes too with the strong black-on-white patterning of line and space that dominates the etching: the empty white space of the river, the horizontal line of boats strongly silhouetted in black, and the fainter line of gray bridge and towers, arranged in successive layers of flat, apparently disconnected planes. It is hard to fit the parts together, to

interpret the spatial and temporal relationships, or even to find a stable location from which to look.

I have exaggerated the spatial and stylistic disjunctions, but only to bring out the unsettling qualities of Whistler's compositions—unsettling particularly to his contemporaries, schooled in viewing practices instilled by a century of realist landscape art. Whistler's refusal to conform to established conventions of realist representation forced them to attend newly to art as patterns of lines on a blank page. The artist's later Venice etchings take the suggestive possibilities of a linear art of omission much further. In *Long Venice* (Figure 4), a thin line of marks trails

FIGURE 4

J. A. M. Whistler

Long Venice, 1879–80

Etching

Cat. 44

FIGURE 5

Seymour Haden

The Breaking Up of the Agamemnon, 1870

Etching

Cat. 17

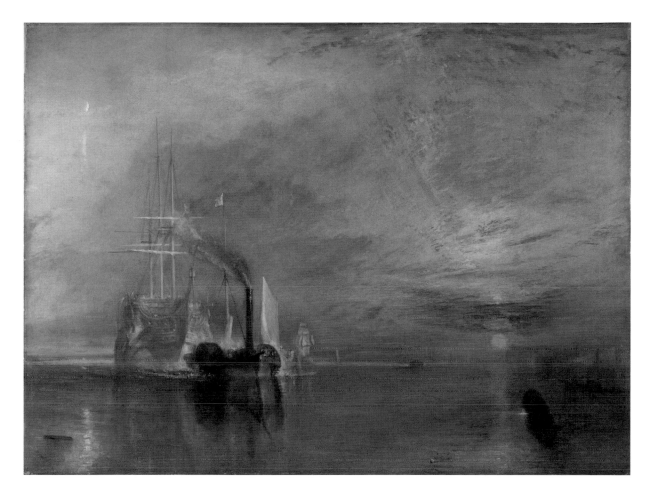

FIGURE 6

J. M. W. Turner

The Fighting Temeraire tugged to her Last Berth to be broken up, 1838

Oil on canvas

90.7 x 121.6 cm

NG524, Turner Bequest, 1856

© The National Gallery, London

across a narrow expanse of blank paper, disciplined into recognizable forms toward the left but diminishing to suggestive scratches on the far right and in the space above.[13] The viewer is led progressively to see more in less as she reads from left to right across the page and upward, constructing from increasingly minimal indications an entire city of light on the horizon, floating on a vast expanse of water and overlooked by the barest suggestions of distant alps among clouds.

Whistler's unconventional *Thames Set* and his magically suggestive Venice etchings continued to influence revival etchers in Britain and America. Both Haden and

the later, self-taught Scottish etcher James McBey took their inspiration from Whistler, but each developed very different aspects of his work. Haden worked side by side with Whistler in the early 1860s on the lower reaches of the Thames (until they fell out spectacularly). Haden's *Breaking Up of the Agamemnon* of 1870 (Figure 5) is in some respects much more conservative than Whistler's compositions. The subject, reminiscent of J. M. W. Turner's 1838 painting *The Fighting Temeraire tugged to her Last Berth to be broken up* (Figure 6), juxtaposes the heroically rendered ship with the classical name (Agamemnon, as we recall, was the Greek leader murdered by his

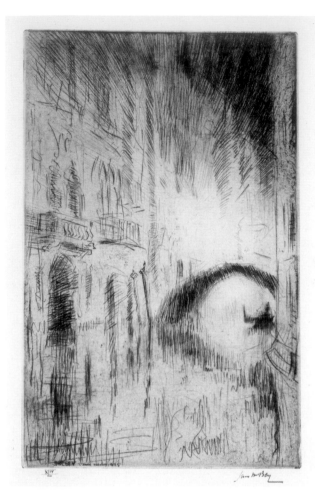

FIGURE 7
James McBey
The Bridge by Night, 1925
Drypoint
Cat. 27

wife) against a setting sun: this is the death of a hero. Haden later repeated the composition in a much larger format using mezzotint to create a striking exhibition piece; this early version, though it is already reaching for grand sentiment, retains a more modest use of beautifully controlled line arranged in layered planes, from dark to light. Hind praised *The Breaking Up of the Agamemnon* as a triumph of masterful line shaping page into space. McBey, on the other hand, looked to Whistler's later Venetian etchings in his graphically furious, barely controlled, yet nonetheless effective evocation of the Bridge of Sighs, *The Bridge by Night* of 1925 (Figure 7). His lines

do not so much follow the contours of Venetian bridge and buildings as conjure them forth, using a private vocabulary of very free strokes that seem to be drawn from *writing*. Haden's carefully differentiated spatial planes and vigorous but controlled line no less than McBey's graphically free scribbles interpreted anew Whistler's "pure" or "true" etching.

Early twentieth-century etchers continued to explore the expressive possibilities of spare line on blank paper while turning to modern subjects or bringing to older European scenes a disorienting new intensity of vision. Ernest David Roth, an American born in Germany, produced a startling image of the Theater Marcellus in Rome in 1914 by ignoring everything but the stark black lines of the ruin, thickened as if with the effort to burn them into consciousness (Figure 8). Roth printed his own work using a slow and laborious technique of applying acid in touches with a feather rather than through acid baths, thus controlling minutely the tonal value of every line. As a reviewer in the *Studio* noted in 1914, Roth was "no sentimentalist . . . but an artist, whose psychological insight can bring home to us the fundamental austerity, the almost sinister sternness" of the architectural scenes he portrays.[14] John Taylor Arms, an American who trained as an architect but fell in love with etching, revisited familiar picturesque sites all over Europe, but portrayed them as void of any signs of life. In *Oviedo, the Holy* of 1937 (Figure 9) the image is lifted above the ordinary by the intensity and intimacy of the vision, which funnels us down a narrow, echoingly empty street into glaring light. The height of the spires beyond is exaggerated by the narrow approach and the unusual proportions of the image. Most striking is the artist's obsessively precise rendering of wall surfaces: the areas in sunlight to either side of the narrow street, for example. An attentive viewer can lose herself in his minutely rendered surfaces until the solidity of stone slips out of reach. In Arms's only image of the American west, *The Valley of the Savery, Wyoming* (Figure 10), the shock of vast and unfamiliar forms is rendered as a striking pattern of long, irregularly curving black lines across expanses of white, cut with knife-sharpness into canyons vertically striped in crisply alternating grays and blacks. The rolling waves of open land and the contrasting canyons seem oddly denatured, as if made of folded cloth and

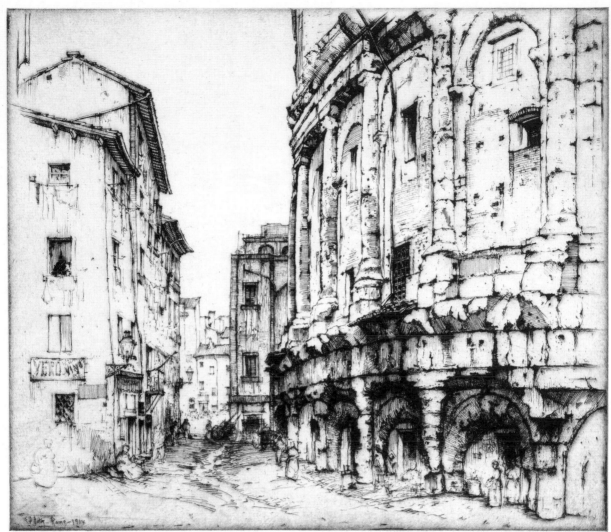

FIGURE 8
E. D. Roth
Theater Marcellus, Rome, 1914
Etching
Cat. 34

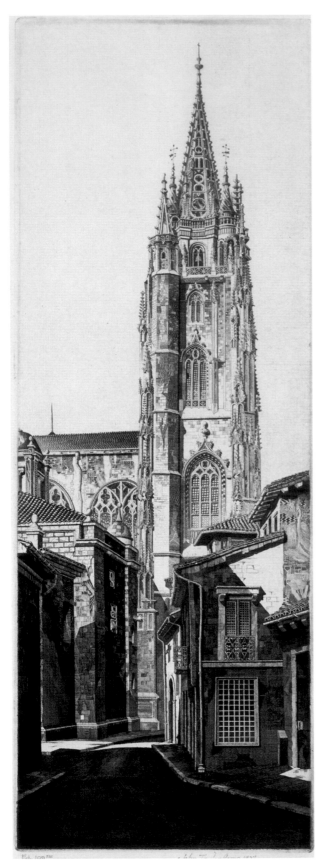

FIGURE 9
J. T. Arms
Oviedo, the Holy, 1937
Etching
Cat. 1

etched crystal, by the intensity of Arms's pattern-making vision. It would be only a short step from this landscape to a fully abstract art.

Etching generally stopped this side of abstraction. But its reduction of a scene to a linear design in black and white nonetheless enabled viewers to see familiar sites differently or to cope with new and unfamiliar ones. Muirhead Bone, a Scot who, like Arms, trained as an architect before he discovered printmaking, often showed buildings hidden under scaffoldings of construction or demolition. Bone's city is continually changing: buildings rising and falling, their facades covered by structural skeletons, while railroads curve around and under the settled picturesque of the older European city. In his *Railway Sheds, Marseilles* (Figure 11), shed roofs and the receding bulk of a high retaining wall echo and oppose the exaggerated swing of tracks past older tenements. The striking curvilinear design suggests a new aesthetic of unadorned structure in motion. The work of E. S. Lumsden is perhaps more stunned than exuberant in one of his many scenes of India, to which he traveled several times. In his *Jodhpur*, probably from around 1928–38 (Figure 12), a mountainous mass is topped by steep-walled Mehrangarh Fort, citadel of power under successive Rajput, Mughal, and British rule, rising directly from its rock and depicted from a low perspective that increases its intimidating scale. The severities of line etching respect the way the stony immensities of the subject resist easy assimilation, though the representation nonetheless imposes some coherence on this distant scene. Yet the shadowed rocky cliffs near the bottom of the vast hill drop unendingly off the edge of the picture space, only briefly broken by a ledge of reflecting water before resuming their fall. This scene, like those of Arms or Roth, is empty of any human figures, its vast whites suggesting the blinding light of arid rock, the hill itself nearly bare of human habitation—an apparently forbidding country.

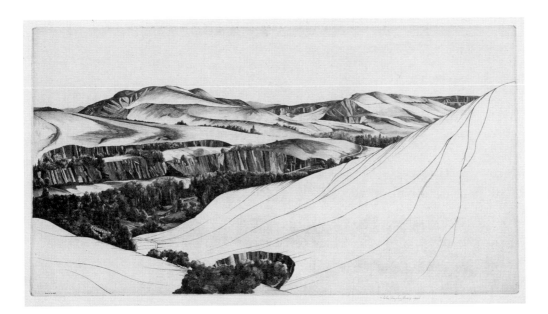

FIGURE 10
J. T. Arms
The Valley of the
Savery, Wyoming,
1934
Etching
Cat. 2

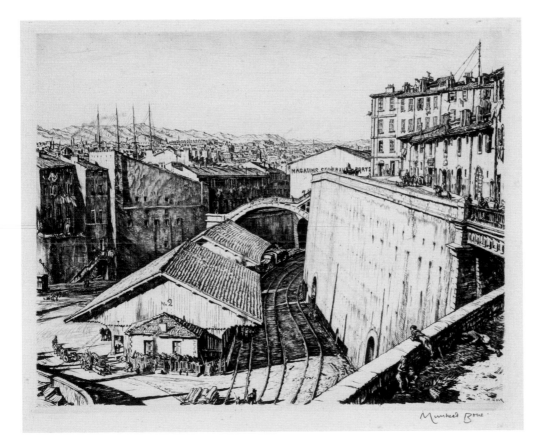

FIGURE 11
Muirhead Bone
Railway Sheds,
Marseilles, 1937
Etching and
drypoint
Cat. 6

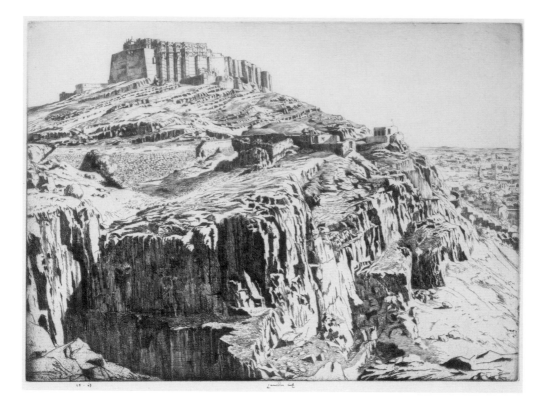

FIGURE 12
E. S. Lumsden
Jodhpur, probably
c. 1928–38
Etching
Cat. 26

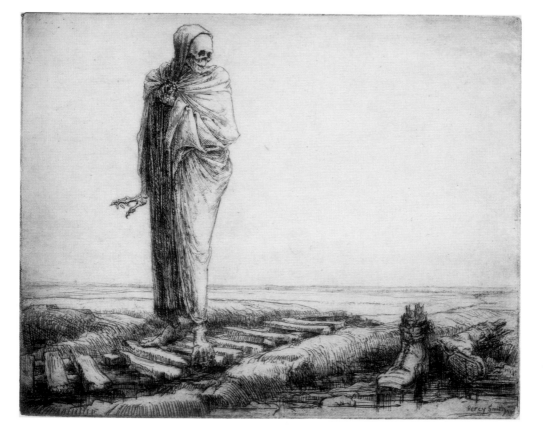

FIGURE 13
Percy Smith
Death Awed,
c. 1918–19
Etching
Cat. 37

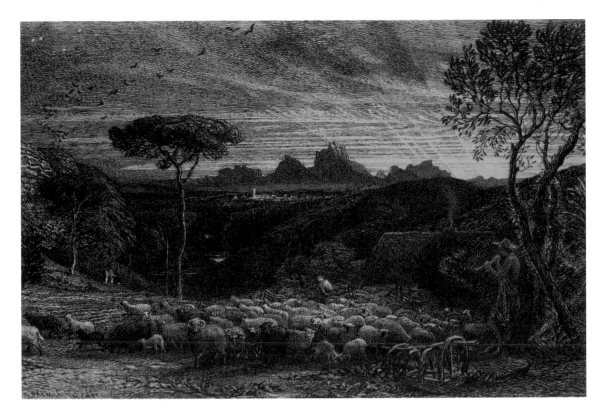

FIGURE 14
Samuel Palmer
Opening the Fold, from *An English Version of the Eclogues of Virgil*, 1883
Etching
Photograph: University of Chicago Library, Special Collections Research Center
Cat. 33

Blank space and spare line tell still more cruelly in the series of allegorical etchings by Percy John Delf Smith in response to World War I. *Death Awed* (Figure 13) is one of his most powerful images. A strangely finical Death, wrapping close the rags around his bones, is viewed from below against a vast and nearly empty landscape into which the wooden ties of a single track disappear. No bush or tree, no human or animal life, breaks the stillness of the flat distance. Nothing has escaped the relentless erasure of ornament, even of flesh, in what we see. Death looks down askance at a pair of boots, empty but for a few shards of bone, mute testament to senseless but thorough killing.

For many artists, however, the real power of etching lay not in what a few lines alone could evoke from the blank page but in the effects of slower and more difficult labor—visual, manual, and interpretative. In France the "intense

physicality" of this side of etching, as Anna Arnar argues in her essay in this volume, could be invoked to magnify the heroic stature of the etcher-artist (and Whistler learned from the French its usefulness to his own self-presentation). In Britain and the United States, it was more often embraced by etchers who identified themselves with the craft culture of print-making. Darkness was as important as light. These artists built up intricate layers of line, printed by slow and laborious methods, or prepared their plates to make etching a tonal as well as linear art, relying on textures and shades of gray and black. In some images, the white page only rarely appears through layers of gloom or densely interwoven black lines, as in the lovingly worked, deeply elegiac etching by Samuel Palmer, *Opening the Fold* (Figure 14), accompanying his translation of Virgil's *Eclogues*. Alternatively, the image itself

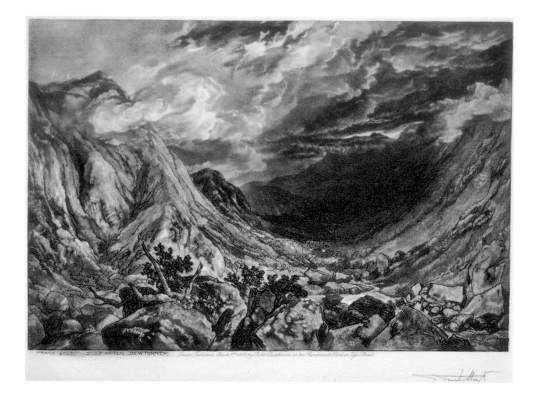

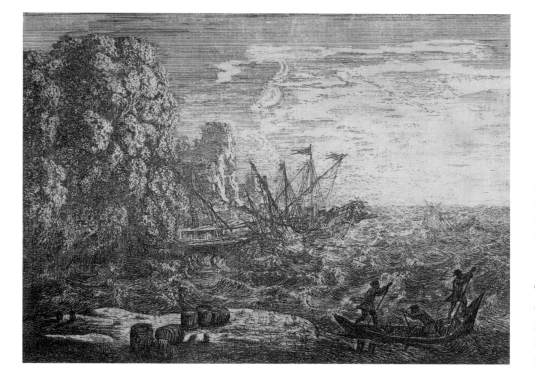

might begin in darkness, to be gradually revealed by scraping out lighter areas. The artist worked to bring to visibility subjects conceived as initially obscured, as in Frank Short's re-creation of an etching and mezzotint by Turner, *Ben Arthur* (Figure 15). Bringing an image slowly from darkness toward light, or building up darkness through linear accumulations, was itself a kind of interpretative thinking.

Writing of the etched work of Claude Lorrain, Palmer might have been describing the effects of his own etchings: the eye "lingers and hesitates with the thought, and is lost and found in a bewilderment of intricate beauty" (see Figure 16). For Palmer, two centuries after Claude, etching's intricacies permitted the mind's eye to pause and linger as he looked back in memory through London's fog and darkness to the visionary pastoral landscapes of his youth, when he was inspired by William Blake. Palmer knew Blake, whom he revered as a prophet, and was deeply impressed by his tiny woodcut illustrations to Virgil's *Eclogues* (Figure 17). It is the extended process of thinking and remembering, guided by the manipulation of materials and the accidents of their behavior, that appealed to Palmer, as it did to other etchers (Roth, Short, Armin Landeck) who valued the laborious craft of working with acid and ink. The slow technique allowed Palmer to observe—with a certain "speculative curiosity"—the reemergence of past inspiration in the "thousand luminous eyes which peer through a finished linear etching":

> [T]he great peculiarity of etching, seems to be that its difficulties are not such as excite the mind to "restless ecstasy," but are an elegant mixture of the manual, chemical and calculative ... [This] sometimes amounts to torture, but, on the whole, it raises and keeps alive a speculative curiosity—it has something of the excitement of gambling, without its guilt and its ruin.

"For these and other reasons," Palmer concludes, "I am inclined to think it the best ... exponent of the artist-author's thoughts."[15]

Palmer generated his lights and shadows entirely through line. Other revival etchers who shared his craft aesthetic experimented with tone. They explored different methods of treating the plate before or during printing to create varied textures and qualities of light and darkness,

FIGURE 17
William Blake
Thenot Remonstrates with Colinet, from Virgil's
Eclogues, 1821
Wood engraving
3.7 x 7.4 cm, image; 3.9 x 7.7 cm, sheet
The Art Institute of Chicago, William McCallin
McKee Memorial Collection, 1934.58

reviving old processes (mezzotint, aquatint) and inventing new ones. Mezzotint had been influentially used earlier in the century by Britain's two greatest landscape painters, Constable and Turner. The process involves covering the metal plate evenly with tiny dots or marks, with the help of a rocker; after the design has been etched, some areas can be scraped or burnished to create lighter tones. Combinations of etched line and mezzotint (literally, the middle tones between white and black) produce the play of lights and shadows that both artists valued highly. Mezzotint was revived by the master etcher and teacher Frank Short, who in the 1880s re-created many of the drawings Turner had made for his own mixed-intaglio series, the *Liber Studiorum*. Turner was recalling late eighteenth-century mezzotints by Richard Earlom after Claude's *Liber Veritatis*, a collection of drawings the artist made as an authentic record of his paintings (see Figure 18). Turner usually etched his own designs but then closely supervised the work of a professional engraver for the mezzotints; the translation of the drawing depends upon the added play of light and shadow. Short's versions met with the approval and encouragement, not lightly given, of the great Turner critic John Ruskin. Yet here, too, one is tempted to say that Short's *Ben Arthur*, though it is notably faithful to Turner, means something different by the end of the nineteenth century. The deep gloom obscuring the long valley, the blasted trees and wreck of rocks in the foreground, the

FIGURE 18
Richard Earlom after Claude Lorrain
A Landscape, 1803
from the *Liber Veritatis*, Vol. III, Pl. 23
Etching and mezzotint
Cat. 12

turbulent clouds overhead, the whole scene viewed through the inks used in printing: these combine to connote for later viewers a landscape of memory, whose imagery of powerful natural destruction (the traces of avalanche and storm) is now understood through its distanced resemblance to urban landscapes in rapid and violent transformation.

Constable's *Hampstead Heath, Stormy Noon, Sand Diggers*, looked at from the same temporal remove, is probably closer to what it meant to the artist himself (Figure 19). The prints in his semi-autobiographical collection *Characteristics of English Landscape Scenery* (1831, 1833) were already landscapes of memory, rich in feeling.

The tonal effects that David Lucas, following Constable's instructions, coaxed from mezzotint are, as Constable's letterpress for the collection makes clear, doubly "characteristic." Mezzotint renders wet, windy sweeps of rain and cloud, lit with glancing, gleaming light—distinctive features of Constable's England and of the visual language through which he expressed his love for it. But his feeling was already retrospective in 1831, recalling the East Anglian canals, locks, mills, and farms of his youth from the distance of London, and the happiness of his brief marriage through his devastating grief at his wife's death. In *Hampstead Heath*, London dazzles in the distance (at the far center on the horizon), just visible from the heights of

FIGURE 19
David Lucas after John Constable
Hampstead Heath, Stormy Noon, Sand Diggers, 1831
Mezzotint
Cat. 25

a vast suburban heath where sand is still dug and carted in an almost rural scene, but rural peace and urban promise can be seen now only through the heavy intervening screen of years and rain.

Short also experimented with aquatint. *A Span of the Battersea Bridge* (Figure 20) contrasts the light mottling effects of acid on the plate (used to give the "transparency" of air seen through the span) with a rougher, darker texture ("for the bridge, which is more sodden in sympathy with the old timbers") achieved by adding sand to the ground.[16] The result is less a riverside idyllic pastoral than an image of industrial decay. Short's favorite subjects, as

Hind described them, were "factory chimneys, stunted, smoke-dried trees, heavy skies, dreary level water, along which barges make their monotonous way":[17] the ingredients of an ex-urban industrial wasteland, for which this view of the stark, sodden timbers of the Battersea railway bridge can stand as bleak emblem.

Hablot Browne, who as "Phiz" collaborated with Charles Dickens to etch illustrations for many of his best novels, usually used a comic graphic style much influenced by the earlier social satires of William Hogarth and the etched political caricatures of Thomas Rowlandson and James Gillray. When faced with the challenge of Dickens's

FIGURE 20
Frank Short
A Span of the Battersea Bridge, 1899
Aquatint
Cat. 35

grim portrayal of London in the 1850s, however, he turned to a mixed technique to create a small number of "dark plates" for *Bleak House*. Using a machine to cover his plates with fine lines, "Phiz" etched the fever-ridden, falling-down slum Dickens called Tom-All-Alone's (Figure 21). The deep gloom on the mechanically ruled plate wonderfully evokes the novel's physically thickened atmosphere of fog, night, contagion, and mud, where propped-up buildings threaten to sink with their inhabitants back to the dense obscurity (literal and figurative) from which Dickens briefly rescued them.

More than half a century later, the American Kerr Eby chose a similar language of overpowering darkness in his etchings of events he witnessed in World War I. In his *September 13, 1918, St. Mihiel (The Great Black Cloud)*

(Figure 22), the grays of aquatint—where acid mottles the metal plate—are further darkened with sandpaper. The great black cloud perhaps recalls the gas that poisoned many soldiers, but it also suggests the crushing darkness of mind that haunted survivors. It occupies three quarters of the picture space, dwarfing a long line of trudging troops and cartloads of wounded arrayed in monotonously repetitive procession, hunched bodies reduced to faceless anonymity and wrapped in a gloom as expressive as it was real.

Urban shadow, though less apocalyptic, is intrinsic to the vision of two American printmakers. A decade after the war, Martin Lewis and Armin Landeck used textured, tinted papers, sand grounds, and dense areas of line to suggest the night streets of New York. Landeck's strangely

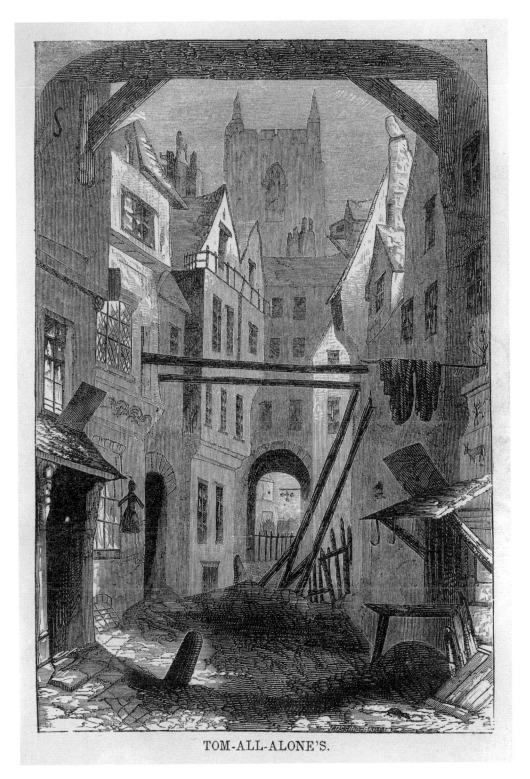

TOM-ALL-ALONE'S.

FIGURE 21
H. K. Browne ("Phiz")
Tom-All-Alone's, from Dickens's *Bleak House*, 1853
Etching
Cat. 8

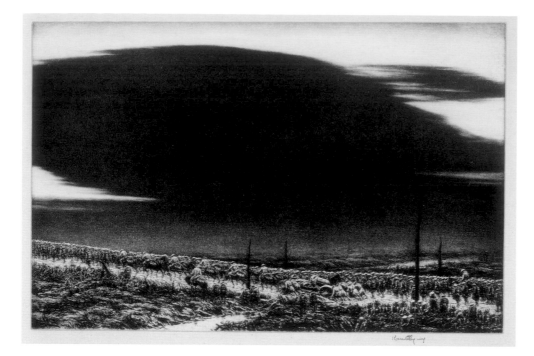

FIGURE 22
Kerr Eby
September 13, 1918, St. Mihiel (The Great Black Cloud), 1934
Etching and aquatint
Cat. 14

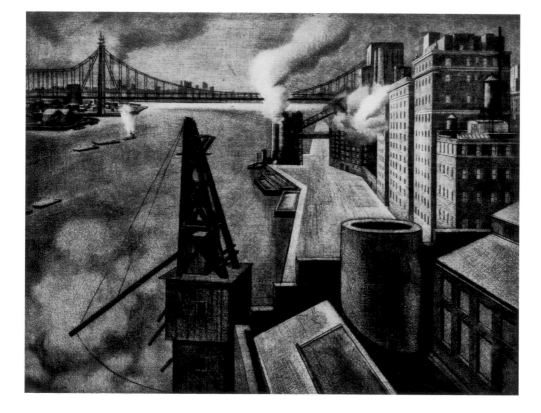

FIGURE 23
Armin Landeck
East River Drive, 1941
Etching
Cat. 20

FIGURE 24
Martin Lewis
The Return, 1925
Drypoint
Cat. 24

geometric urban views—as in *East River Drive* of 1941 (Figure 23)—convey the silent emptiness of outsize, featureless streets and blank-windowed buildings behind the huge smokestacks and cranes that line a working river. The only signs of life in his urban ghost town are the smoke and steam from barge and factory. In this still-life study of giant cylinders and rectangles, Landeck finds formal beauty in an otherwise bleak view of the modern city. For Lewis, by contrast, the human figure is crucial to his images of a city's lonely populousness. Influenced by the asymmetries and

simplifications of Japanese art (see his *The Return*, Figure 24), Lewis's New York etchings seize on random, isolated encounters, less narrative than emblematic in their glimpses of urban life: a woman hanging out her stockings, an evening rendezvous outside a corner speakeasy, or, in *East Side Night, Williamsburg Bridge* (Figure 25), an apparently lone man with his back to us outside a men's room on an elevated bridge. (Is he waiting for someone? Turning from parting with the woman seen leaving the scene at lower left? Or just contemplating the lighted windows in

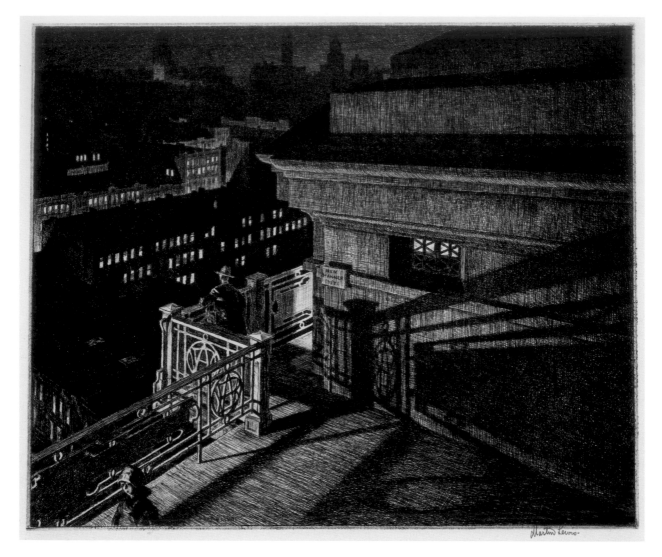

FIGURE 25
Martin Lewis
East Side Night, Williamsburg Bridge, 1928
Etching
Cat. 23

the dark buildings of the urban canyon below?) The sign for the men's room, in both English and German, is a trace of the crowded immigrant streets of the city's Lower East Side from which he has come.

The Depression—prospectively present in Lewis's *East Side*, retrospectively remembered in Landeck's *East River*—saw the end of the etching revival. Photography and film displaced it as the representational arts of modern life. Yet etching's interpretative lines and shadows, its capacities for finding new patterns in old scenes and rendering the strangeness of the new, are other than those of the artist with camera. These modest works—neither documents nor fictions—record with "speculative curiosity" their makers' visions of a changing world mediated by the work of hand, needle, acid, ink, and metal. They are not quite poetry, but more than journalism, less innovative than avant-garde painting but more formally self-conscious than much realist art. For several generations, etching occupied a unique place as art's "writing" of modern life.

NOTES

1. Many etchers initially trained as architects or engineers or in the applied arts; they identified themselves as illustrators, graphic designers, or printmakers, not painters. Many were women, though their work is vastly underrepresented in most museum collections; for an excellent discussion of the many reasons for this, see Gladys Engel Lang and Kurt Lang, *Etched in Memory: The Building and Survival of Artistic Reputation* (Chapel Hill: University of North Carolina Press, 1990). The second chapter of this book is a useful review of the history of etching and the etching revival in France, Britain, and the United States.

2. On the rhetoric through which etching was promoted, see Emma Chambers, *An Indolent and Blundering Art? The Etching Revival and the Redefinition of Etching in England, 1838–1892* (Aldershot: Ashgate, 1999); and, for France, the introductory essays and documents reproduced in Janine Bailly-Herzberg, *L'eau-forte de peintre au dix-neuvième siècle: La Société des Aquafortistes, 1862–1867,* 2 vols. (Paris: Léonce Laget, 1972). See also essays by Martha Tedeschi and Anna Arnar in this volume.

3. Peter Parshall develops this argument in "A Darker Side of Light: Prints, Privacy and Possession," essay in the forthcoming catalogue for a 2009 exhibition at the National Gallery of Art, Washington.

4. Philip Gilbert Hamerton, *Etching and Etchers* (London: Macmillan, 1868), xv.

5. A. M. Hind, *A Short History of Engraving and Etching* (London: Archibald Constable, 1908), 327.

6. Hamerton, *Etching and Etchers*, 142. Hamerton was particularly given to using the terms "masculine" or "manliness" to describe the manner of "true" line etchers; see, for example, his comments on the "unusual manliness" of Turner's line and his "masculine perception" (*Etching and Etchers*, 85, 86).

7. Hind, *A Short History*, 324.

8. Hamerton, *Etching and Etchers*, 113.

9. Hind, *A Short History*, 326.

10. "Il serait même difficile à l'artiste de ne pas décrire sur la planche sa personnalité la plus intime." Charles Baudelaire, "Peintres et aquafortistes" (1862), in *Oeuvres complètes*, ed. Claude Pichois (Paris: Gallimard, 1976), 2:741; my somewhat free translation.

11. "Parmi les différentes expressions de l'art plastique, l'eau-forte est celle qui se rapproche le plus de l'expression littéraire." Ibid., 2:736.

12. Chambers, *An Indolent and Blundering Art?*, 135–42.

13. *Long Venice* is from the *Second Set*, printed by Whistler from plates etched in Venice and shown at the Fine Art Society, London, in 1883, in an exhibition Whistler designed to the smallest details (the yellow livery of a servant handing out catalogues, white frames for the etchings, softened light, colored walls) as a "harmony" in yellow, gray, black, and white.

14. E. Madden, "Some Etchings by Ernest D. Roth," *International Studio* 54 (1914–15): 13.

15. A. H. Palmer, *The Life and Letters of Samuel Palmer, Painter and Etcher* (London: Seeley, 1892), 336; quoted in Raymond Lister, *Samuel Palmer and His Etchings* (London: Faber, 1969), 73.

16. Short pointed this out in a technical note in Ernest S. Lumsden, *The Art of Etching* (London: Seeley, Service, 1925), 339.

17. Frederick Wedmore, *Etching in England* (London: G. Bell, 1895), 97–98.

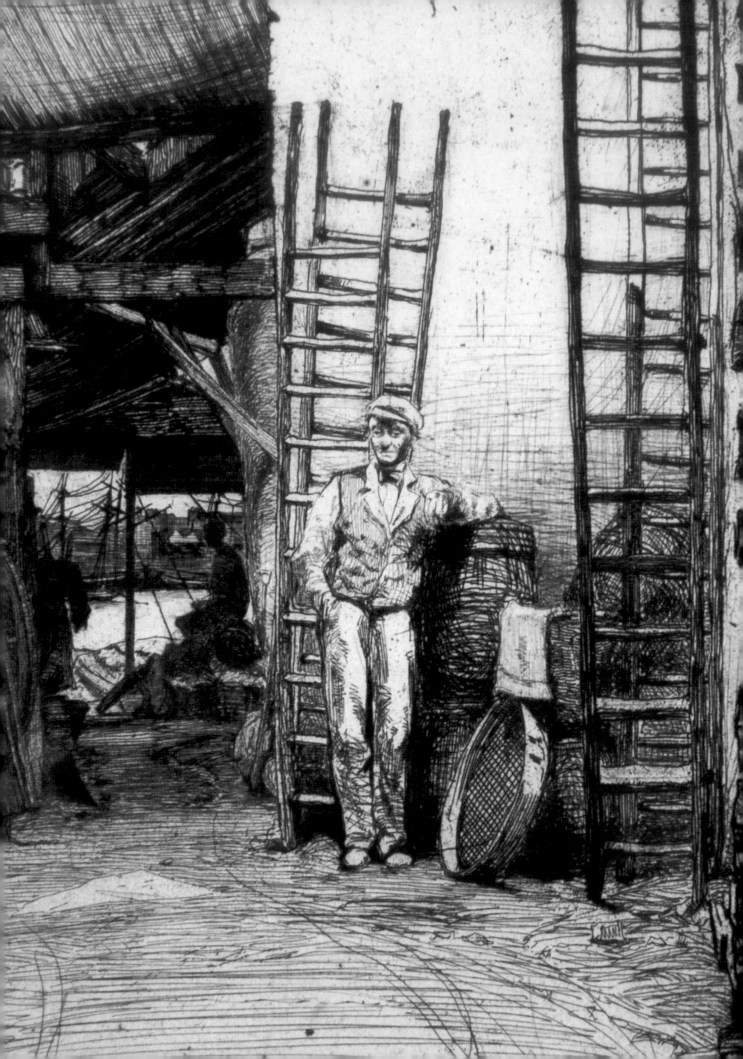

MARTHA TEDESCHI

The New Language of Etching in Nineteenth-Century England

SOMETIME AROUND 1850, the medium of etching began to appropriate many of the associations of handwriting. Just as an individual's penmanship, or "hand," was thought to communicate his or her character through the linear formation of letters and sentences, it was argued that the lines of an etching offered the unmediated expression of an artist's thoughts and feelings. It is not difficult to understand why etching, of all printmaking techniques, could be championed as a kind of equivalent for the physical act of writing. After all, it is arguably the least laborious print medium. In the initial execution of the design on the varnished copper plate, the artist uses acid rather than physical force to incise the lines into the metal; strength and exertion are taken out of the equation, allowing the etcher an intellectual freedom similar to that of an author. In comparing etching to engraving in his 1895 treatise, Manchester painter-printmaker Hugh Paton asserted, "in etching, the needle glides over the copper and cuts the wax without resistance; it is as free, in fact, as the pencil upon paper, freer than the pen, and the result is a vivacity of line and force of expression which the colder art knows not."[1]

In its simplest form, the act of etching is unencumbered by technical paraphernalia. Very much like an author sitting down to write at a desk, the artist faces a worktable on which is placed a square of thin copper that has been evenly covered with a varnish ground. In the nineteenth century, most plates were more or less the size of a piece of writing paper. Grasping the handle of the etching needle between thumb and forefinger, as one would hold a pen or pencil, the artist begins to remove the varnish with light strokes of the needle across the plate. There is no need to apply pressure; the point of the needle easily reveals the warm yellow glow of the copper as the ground is gently scraped away, one line at a time. Loops, curls, dots, blunt marks, or long graceful arcs are as freely rendered as letters in the alphabet, allowing the artist's thoughts to flow without the distraction of physical effort or mechanical manipulation. John Constable's few original etchings (for example, Figure 26) exemplified this natural freedom of execution long before the etching revival had popularized sketchy technique; their calligraphic flourishes stand in sharp contrast to the heavily worked, tonal surfaces of David Lucas's mezzotint translations of Constable's canvases (see Figure 19). In fact, so basically alike are the processes of etching and writing that the self-taught French etcher Charles Meryon was encouraged in several instances to write verses of poetry on his copper plates, as in *Verses Dedicated to Eugène Bléry, No. 2* (Figure 27).

In part because of this physical affinity between the acts of writing and etching, the medium of etching could easily be harnessed to new aesthetic ideas that privileged the artist's intellect over laborious execution and encouraged the spontaneous recording of modern life. In nineteenth-century Britain, etching was increasingly promoted as a new language, offering the viewer a direct connection to the hand and mind of the artist. Interestingly, the English revival of etching was itself largely accomplished through the careful crafting of a new vocabulary by art writers and artists, who set out to construct a revised reputation for the medium while dispelling old, unhelpful associations.

DETAIL, CAT. 43

FIGURE 26
John Constable
An Old Bridge at Salisbury, c. 1826
Etching
11.6 x 18 cm, plate; 12.8 x 18.5 cm, chine; 30.5 x 44.7 cm, sheet
The Art Institute of Chicago, Gift of Dorothy Braude Edinburg to the
Harry B. and Bessie K. Braude Memorial Collection, 1991.614

The rhetoric and politics surrounding the promotion of etching in the second half of the nineteenth century were marked by two major strategies, both of which involved exclusion. The first approach was the removal of etching from the largely amateur realm it had hitherto occupied and the reconstruction of its profile as a professional art practiced by painters, the producers of high art. Etching in England, especially, had been a popular drawing-room activity in polite society during much of the nineteenth century, and had become associated particularly with the reproduction of young ladies' pen-and-ink drawings. The second tactic was to position etching as a refined, intellectual art that was practiced, understood, and collected only by "the few," as distinguished from the industry of reproductive printmaking for "the many."[2] The first strategy reflects the intense competition experienced by artists in the last decades of the nineteenth century, as their ranks swelled to unprecedented numbers. The second tactic—cultivating an audience that regarded itself as intellectually advanced—disassociated etching from mass-produced reproductive prints and responded to the emergence of a new elite class of professionals who rejected the trappings of mass culture.

Seymour Haden was the earliest and most ardent spokesman for the movement as well as one of etching's most prolific practitioners. The rejection of his etchings

by the Royal Academy in 1850 stimulated his personal campaign to achieve professional recognition for the medium. Haden joined the Société des Aquafortistes, and in 1864, his etchings were featured in an article by the critic Philippe Burty in the *Gazette des beaux-arts*.[3] This article, and the publication in 1865–66 of Haden's first portfolio of etchings, *Études à l'eau-forte*, may be taken as the first visible signs of an English "revival" movement.[4] Haden's written declaration of battle also burst onto the scene in 1866 in the form of an article entitled "About Etching."[5]

Haden, aided and abetted by the English art critic Philip Hamerton[6] and the master printer Frederick Goulding,[7] and by a small group of other artists, critics, and dealers, constructed a new descriptive and promotional vocabulary for original etching. In the nineteenth-century art market, various types of prints were recognized as speaking distinct languages that allowed them to reach particular audiences. Reproductive engraving and mezzotint were considered ideal for carrying moralizing stories into every home. For example, in 1868 when the *Art Journal* reviewed Auguste Blanchard's engraving after Holman Hunt's *Finding of the Saviour in the Temple*, the writer commented, "The story is written in a language that all can read and understand."[8] A few years earlier, Hamerton had characterized the language of etching in quite opposite terms:

> There are certain forms of art so strangely abstracted and abbreviated that very great knowledge is required in the spectator to read them at all, just as it is necessary to understand a language thoroughly if we would read letters written in it in a hurried handwriting, full of marks and abbreviations peculiar to the individual writer.[9]

Through this rather brilliant and suggestive analogy, Hamerton managed to define the language of etching as intellectual, highly personal, and intelligible only to the cultivated few. It is one example of many in which Hamerton, Haden, and others adapted the language of art writing to the aesthetic vocabulary of the professional painter-etcher; they thus promoted a particular set of associations in the viewer—and potential purchaser—of original etchings.

Haden's brother-in-law was James McNeill Whistler. Despite his deliberate posture as a bohemian outsider—

FIGURE 27
Charles Meryon
Verses Dedicated to Eugène Bléry, No. 2, 1854
Etching
12.7 x 7 cm, plate; 21.6 x 12.8 cm, sheet
The Art Institute of Chicago, Elizabeth Hammond Stickney Collection, 1909.230

which he could claim as an American trained in Paris—Whistler became the most influential painter-etcher in England by virtue of his productivity in the medium and his highly visible efforts toward the reform of printmaking aesthetics and audiences. It was Whistler who established etching production methods designed to create differentiated, choice impressions that would

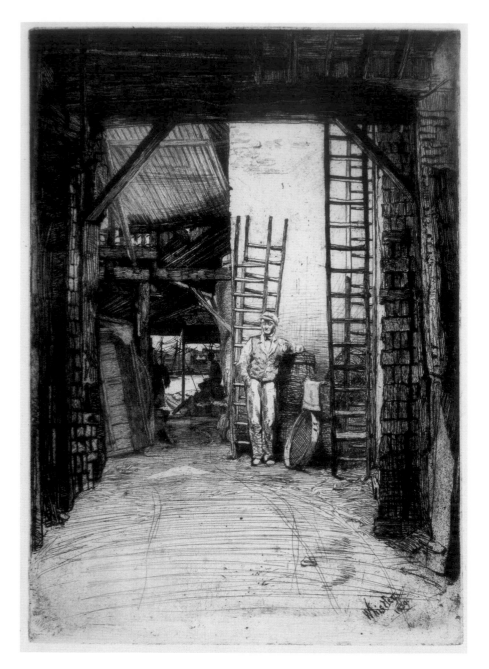

FIGURE 28
J. A. M. Whistler
The Lime-burner, 1859
Etching
Cat. 43

engage connoisseurs. These practices included the use of antique, Asian, and colored papers; the manipulation of surface tone in printing; and the development of a given image through multiple states, proofs, and ink colors.

Whistler also developed in his etchings an aesthetic of highly individualized mark-making, which he applied to modern urban subject matter. In his *Thames Set* etchings of 1859, such as *The Lime-burner* (Figure 28) and *Black Lion Wharf* (Figure 29), he married odd photo-

graphic perspectives and realist, almost documentary intentions with a highly personal "handwriting" that ranged widely from bold, stark slashes to faint, suggestive scratches. As we see in *Soup for Three Sous* (Figure 30), another etching of the same moment, he was already starting to leave large expanses of his plate unmarked, allowing the white of the paper to play an active role in the composition of the print. Whistler carried this strategy to the extreme beginning in 1880, with minimally etched

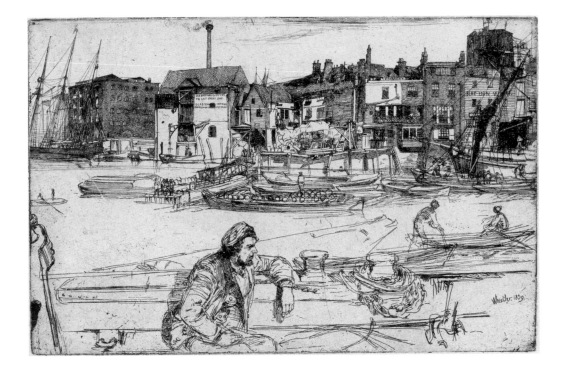

FIGURE 29
J. A. M. Whistler
Black Lion Wharf,
1859
Etching and
drypoint
Cat. 42

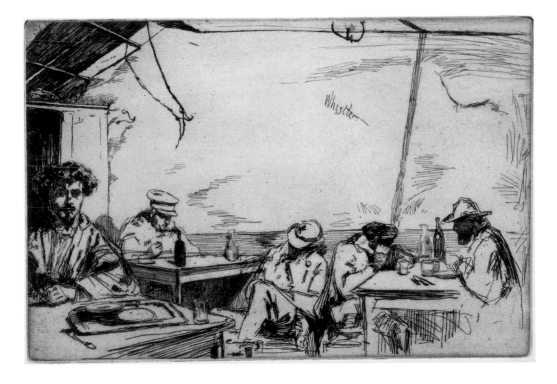

FIGURE 30
J. A. M. Whistler
Soup for Three
Sous, 1859
Etching and
drypoint
Cat. 45

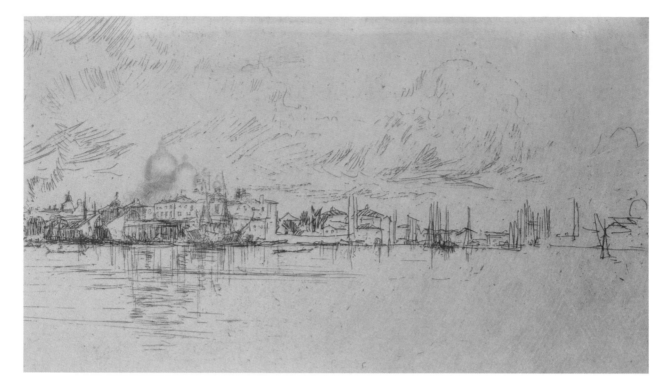

FIGURE 31
J. A. M. Whistler
Long Venice, 1879–80 [detail]
Etching
Cat. 44

plates such as *Long Venice* (see detail, Figure 31). The few lines "written" across the blank page—especially when printed by the artist with a fine film of surface tone—are enough to engage the connoisseur's imagination and transform the flat surface into an evocative seascape. In France, Félix Buhot similarly developed a new vocabulary for personalizing his etchings, despite his very different printmaking aesthetic. Utilizing a wide range of experimental intaglio techniques enhanced with retroussage, he frequently surrounded his depictions of the modern city, such as we see in *A Landing in England* (Figure 32, detail of left margin), with eccentric frames bearing vignettes and "remarques." These imaginative elements acted as small poems tangentially related to the central story (see Figure 53), adding special, touches for the delectation of cultivated collectors.

Much of the language associated with the etching movement was designed to foster notions of exclusivity.

The work of amateurs and women, who had until recently dominated the practice in England, was systematically excluded from the canon of modern etching on grounds of lesser training, quality, and seriousness of purpose. In *About Etching*, Haden argued:

> But of all the modern misapprehensions connected with Etching—once accounted an art in which only a master could excel—is that which supposes it to be particularly suited to the half-educated artist.... For myself I am well persuaded that Etching, of all the arts, is the one least fitted to the amateur.[10]

Also exclusive was the strategy of characterizing etching as a kind of coded language unfathomable to the general public and only appreciable by individuals of superior class and intellect. Charles Baudelaire had written in his "Painters and Etchers" of 1862 that etching was too aristocratic and too personal to gain popular appeal.[11] Hamerton

Longuevilles."[13] At stake in promoting etching as a commodity for the elite was the necessity of distinguishing it from art forms that had achieved widespread popularity, and had as a result become devalued through industrial mass production and distribution. In 1887 New York dealer Frederick Keppel spelled out the potential dangers if etching were to gain wide popularity: "its true artistic side may be ignored; quantity may be considered rather than quality; the art may be 'boomed' and exploited for sordid commercial ends, and men who are incapable of it as an art may ply the making of etchings as a trade."[14]

The aesthetics, subject matter, and production methods promoted by agents of the revival helped ensure that this would not be the fate of modern etching. Wedmore wrote with more than a touch of sarcasm:

> There are perhaps certain conditions under which an etching might interest the outside public. If it were impressive by mere size . . . if it were obviously elaborate, if it were "soft," if it presented a commonplace theme . . . then it is quite possible the outside public might rush to become its purchaser.[15]

Wedmore's statement shows an understanding of the various points at which new etching diverged from popular taste; his reiteration of the term "outside public" also suggests the exclusive frame of mind of the movement and its direct appeal to an audience that wanted to think of itself as "inside" the elite circle of high art. His reference to scale and elaboration points to the issues of labor and finish, areas in which the modern painter's etching radically diverged from popular Victorian taste. Speed of execution, intimate size, economy in the use of lines, selectivity of vision, and suggestiveness rather than elaboration in draftsmanship were now the key elements informing the aesthetics of etching. Yet these

turned the medium's elite attraction to advantage in *Etching and Etchers*, asserting that "indifference to etching is wholly incompatible with high culture." He continued, "It is a matter less for regret than congratulation that an art should exist safe from the baneful influence of vulgar patronage."[12]

Decades later, critic Frederick Wedmore was still fostering the notion of aristocratic discrimination: "The true print-lover can talk about different papers—old French, old Dutch, old English, Japanese—as the connoisseur of clarets talks of Pontet Canets and Pichon

new guidelines, which required the collector to pay for work that was not visible and details that were left out, ran completely counter to the high exchange value Victorian audiences accorded to minute execution, realistic depiction, and time-consuming labor.

In England, far more than in France, the challenge for painter-printmakers was to impart to their original etchings a visual language, as well as a marketing language, that would firmly effect a break with the popular engravings trade. As they discovered, this was not so easily done. As late as 1880, Whistler's Venice etchings were criticized for being "of unimportant dimensions, and of the slightest workmanship.... They rather resemble vague first intentions."[16] In the same vein, a popular guide for buying art for the home informed its readers, "to the general taste Mr. Whistler's ragged style of execution is absolutely without meaning, and Mr. Legros's figures are too unpleasing, too rigid, too slight to be attractive except in the eyes of those who are educated in etching."[17]

The ability to "read" a rapid, spontaneous sketch executed in etching, to appreciate each line as a direct expression of the artist's intellect, became in itself a sign of prestige. Hamerton explained that uneducated audiences were most likely to be attracted to machine-work and suggested that "[t]he uninformed spectator admires execution for itself, as handicraft, with little reference to its meaning; the true judge calls that the best execution which expresses the most."[18] Later, using a literary analogy, he attacked the visible traces of labor as a kind of unsavory distraction from enjoyment of the pure work of art: "Whatever there is of toil and trouble in art should be kept as much as possible out of sight, and conquered in the preliminary and preparatory training. We do not wish to see the poet squeezing his brains for similes or consulting the rhyming dictionary."[19] Instead, speed of execution was advocated as the best means for capturing the first blush of the artist's inspiration. Haden, taking aim at the engraving industry in *About Etching*, argued that "the comparison of the etching needle with the burin is the comparison of the pen with the plow." In his view, the "suppleness, liberty, [and] rapidity" of etching resulted in "directness of utterance ... as personal as handwriting," while the "mechanical effort" of engraving inevitably produced an effect that was "cold, constrained and uninteresting" because it lacked "mental effort."[20]

Thus detailed execution, time-consuming labor, and high finish were now portrayed as negative elements, responsible for sapping much popular, realist art of its honesty, individuality, and meaning. Promotion of the new aesthetic meant proposing an alternative set of artistic criteria that could be translated in the marketplace into monetary value. Because etching was marketed as a direct, unmediated link to the mind of the artist, the character of the painter-etcher himself (he is inevitably promoted as male) became a principal component of value. As early as 1858, Whistler had decorated the title page of his *French Set* with a slight, spontaneous etching of himself sketching outdoors (Figure 33), a clear announcement of his disdain for the high finish and narrative subject matter that dominated the engraving trade. In *Etching and Etchers*, Hamerton described the true painter-etcher as decisive, passionate, selective, frank, and individual, explaining that "etching is eminently a straightforward art ... no art is so entirely honest." Speed of execution was given an exchange value by being equated with careful observation and decisive draftsmanship: "The way to attain true speed is to spend a great deal of time in looking, and having decided upon the strokes to be laid, lay them at once and leave them."[21]

Critics used the etchings of Seymour Haden to exemplify the new aesthetic, while holding up his personal character as the ideal of the painter-etcher. In Haden's case, art writers seized upon attributes of directness and appeal to the intellect. In 1867 British poet and art critic Francis Turner Palgrave wrote, "Mr. Haden's etchings take no pains to allure the ordinary spectator ... they tell their tale by the broadest and simplest means." He added that Haden's etched work "will appeal to the higher and better balanced mind, which always ultimately gives the law and forms the standard for the lower organization."[22] Haden himself cleverly addressed the issues of artistic labor and character by selecting his *Hands Etching—O Laborum* (Figure 34) as the title plate for his *Études à l'eau-forte* of 1866.[23] The Latin title derived from Horace was sufficient to earmark the print for educated audiences. Moreover, the image of the artist's hands at work on an etching plate conveyed several key messages: the etching as a handcrafted rather than mass-produced object, the artist's hand as a direct extension of his mind, and finally the manly competence of the true artist as embodied by his hands.

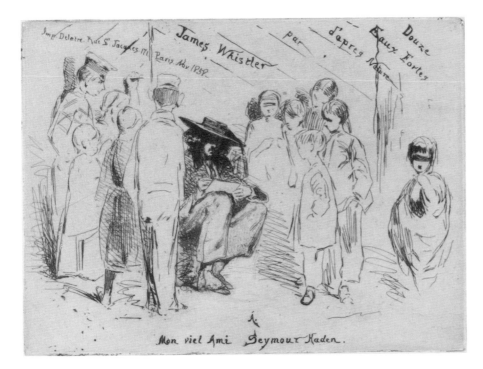

FIGURE 33
J. A. M. Whistler
Title to the French Set, 1858
Etching
11.1 x 14.7 cm, plate; 28.8 x 34 cm,
sheet
The Art Institute of Chicago,
Bryan Lathrop Collection,
1934.645

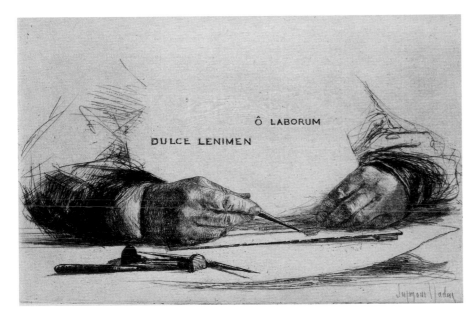

FIGURE 34
Seymour Haden
*Hands Etching—
O Laborum*, 1865
Etching and drypoint
Cat. 18

The attribute of masculinity became part of the new language of etching. Hamerton prefaced *Etching and Etchers* in 1868 by stating that "a treatise on etching is necessarily a treatise on the mental powers of great men."[24] As we have seen, there was much at stake in disassociating etching from amateur production, and the identification of amateur work as "feminine" was a principal strategy for effecting this separation. In his article on Haden's

etchings, Palgrave characterized his era as one in which "pure reason and the higher types of manliness appear to have fallen into a state of comparative feebleness or disfavour."[25] Haden's "masculine command of his means" was demonstrated by his confident wielding of the etching needle in such subjects as *The Breaking Up of the Agamemnon* (see Helsinger, Figure 5).[26] Wedmore waxed particularly enthusiastic on Haden's prowess in an article

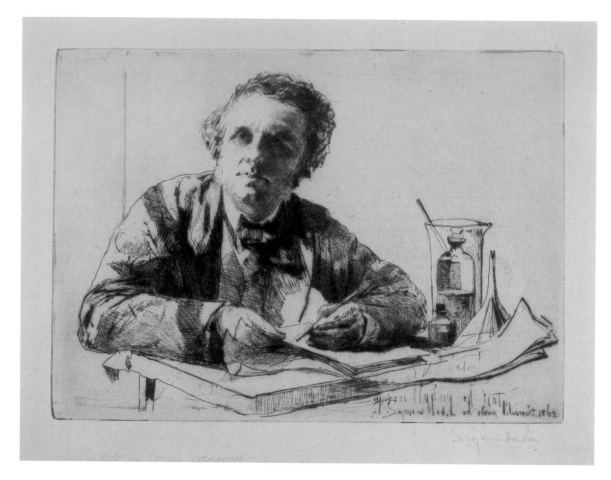

FIGURE 35
Seymour Haden
Portrait of Francis Seymour Haden, No. 11 (while Etching), 1862
Etching and drypoint
19.6 x 26.8 cm, plate; 24.7 x 32.1 cm, sheet
The Art Institute of Chicago, Bryan Lathrop Collection, 1934.603

of 1888, banishing forever the "pretty," "feminine," and "elaborate" reputation of the etching medium:

> Now if there is one thing that Mr. Haden . . . exhibits in excess, it is strength. If there is one thing . . . he sometimes withholds from us, it is exquisiteness. With him— it may be as with Rembrandt and with Browning— an obvious exquisiteness is a luxury he affords only seldom. His is no light and elegant draught; the wine "pulses in might" from him. He is nothing if not potent.[27]

The banishment of the amateur from the realm of etching required that an alternative history of the medium be written. Promoters and practitioners of modern etching traced their lineage back to historical moments when professional painters had created original etchings as independent works of art. They gave seventeenth-century Dutch etchers particular attention, presumably because their naturalistic style and subject matter, coupled with the healthy market for etchings they enjoyed, engaged nineteenth-century concerns and ambitions. As "the great representative etcher of all time," Rembrandt came to embody this heritage; modern painter-etchers were hailed as "modern disciples of Rembrandt."[28] The free, expressive line work and strong draftsmanship evident in Rembrandt's etchings helped validate the aesthetic of

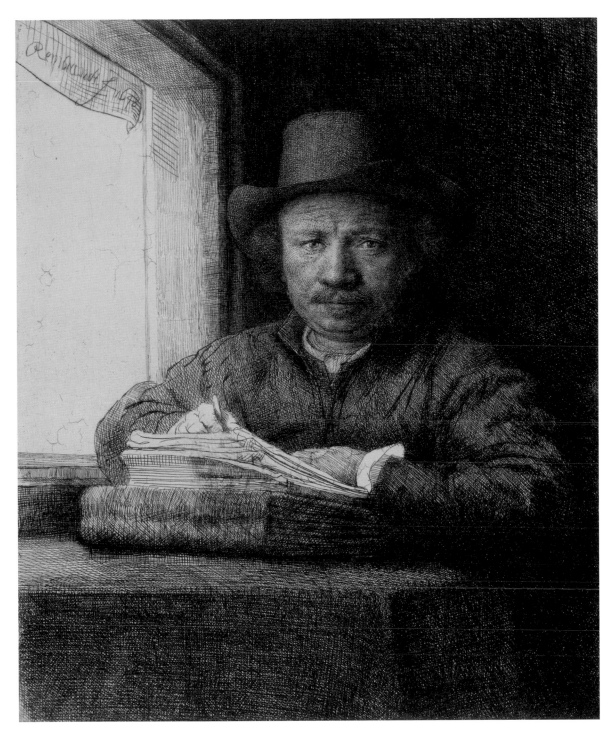

FIGURE 36

Rembrandt van Rijn

Self-Portrait at a Window, Drawing on an Etching Plate, 1648

Etching, drypoint, and burin

16 x 13 cm, plate; 16.6 x 13.6 cm, sheet

The Art Institute of Chicago, Amanda S. Johnson and Marion J. Livingston

Endowment and Clarence Buckingham Collection, 2004.88

modern etching. He and his followers represented a tradition in which the medium was taken seriously by artists and patrons. That tradition allowed the etching movement to position itself as a "revival," forging a legitimizing link between the present and a time-honored past. Haden made strategic use of his personal collection of Rembrandt etchings, loaning them for exhibitions at the Burlington Fine Arts Club and The Fine Art Society, and writing extensively on the history and connoisseurship of Rembrandt's prints.[29] He also set himself up as a modern successor to Rembrandt in his *Portrait of Francis Seymour Haden, No. 11 (while Etching)* (Figure 35). This image of the artist, emphasizing the connection between mind and hand, clearly established a lineage to the Dutch master, whose appearance was known through etched self-portraits such as the contemplative *Self-Portrait at a Window, Drawing on an Etching Plate* (Figure 36).

Etchings by Rembrandt, especially impressions in rare or unique states with distinguished provenances, began to fetch unprecedented prices on the market. The entire art world was stunned when an impression of Rembrandt's *Hundred Guilder Print* (*Christ Healing the Sick*) sold at auction in 1867 for £1,180 ($7,965). While the *Art Journal* called this "something like insanity," the

event immensely boosted not only Rembrandt's reputation but also the prestige value of modern etching.[30] In subsequent decades, as his prices continued to climb, Rembrandt's prints demonstrated that painters' etchings, although multiples, could be appreciated as valuable expressions of artistic individuality. An original etching, like an autograph letter or handwritten poem, was the direct creation of the artist's hand, and thus of his heart, character, and intellect: "By this direct communication between the artist and his admirer, an intimacy is established which brings the amateur [connoisseur] face to face, as it were, with the master's mind, for no agent, or middleman, stands between."[31]

Etching's "revived" reputation now relied on the perceived communion this autographic medium facilitated between artist and patron, a notion fostered by the language, aesthetics, and production methods of painter-printmakers and their supporters. Toward the end of the nineteenth century, this newly constructed language of intimacy, subjectivity, and discernment surrounding painters' etchings contributed to an emerging form of class distinction that was more intellectual than economic in its basis, that between the owners of original prints and the owners of printed reproductions.[32]

NOTES

1. Hugh Paton, *Etching, Drypoint, Mezzotint: The Whole Art of the Painter-Etcher* (London: Raithby, Lawrence; Leicester: De Montfort Press, 1895), 7.

2. The terms "the many" and "the few" reflect nineteenth-century language; these terms are found consistently in the literature on prints throughout the Victorian period.

3. Philippe Burty, "L'oeuvre de M. Francis Seymour Haden," *Gazette des beaux-arts* 17 (1864): 271–87, 356–66.

4. *Études à l'eau-forte* was published in both Paris and London, and contained a catalogue of Haden's etchings by Burty. The set included twenty-five prints and was intended to be issued in an edition of 250; Schneiderman states that the eventual run was only 180. On this and other details of the publication, see Richard S. Schneiderman, *A Catalogue Raisonné of the Prints of Sir Francis Seymour Haden* (London: R. Garton, 1983), 26.

5. Seymour Haden, "About Etching," *Fine Arts Quarterly Review*, n.s., 1 (1866): 145–60. Republished as *About Etching: Notes by Mr. Seymour Haden on a Collection of Etchings and Engravings*

by the Great Masters, lent by Him to The Fine Art Society to Illustrate the Subject of Etching (London: The Fine Art Society, 1878–79).

6. Philip Gilbert Hamerton was the critic most intimately tied to the construction of the etching "revival"; his role in England can be likened to that of Philippe Burty in France. A painter and etcher himself, he had become a great admirer of French etching and considered Alphonse Cadart's monthly publication of etchings by the Société des Aquafortistes to be "the perfection of good taste." In his 1864 essay on French etching, he formulated many of the central arguments of the movement, advocating the spontaneous sketch and asserting that etching is an intellectual art, which, "to the ordinary spectator . . . is uninteresting, because unintelligible." He concluded by placing the burden of the "revival" on the art-buying public, suggesting that collectors could shape taste by "resolutely refusing to buy any but *original* etchings." In recommending such a boycott of reproductive work, Hamerton empowered the consumer to demand a more direct relationship with the artist. Hamerton,

"Modern Etching in France," *Fine Arts Quarterly Review* 2 (1864): 69.

7. Frederick Goulding was in essence the official printer to the English etching movement, as August Delâtre had been to the Société des Aquafortistes in Paris. Goulding demonstrated how a sensitive wiping of each plate—leaving more or less ink on the surface depending on particular needs—could enhance the effectiveness of the image. His careful handwork substantially altered the aesthetics of modern etching by introducing the element of artistic printing. He replaced the crisp printing style associated with the London Etching Club with a more varied approach, which encouraged artists to see the printing of their etchings, including the selection of ink color and paper type, as an integral part of creating the work of art. Whistler took this approach to the extreme in some of his Venice etchings, manipulating surface tone to such an extent that each impression essentially became a monotype. The new attitude toward printing gave primacy to the role of the artist's hand and mind in the production process.

8. "Finding of the Saviour in the Temple," *Art Journal* 7 (May 1868): 100.

9. Hamerton, "Modern Etching in France," 69.

10. Haden, *About Etching*, 25.

11. Charles Baudelaire, "Peintres et aquafortistes" (1862), quoted in Katharine A. Lochnan, *The Etchings of James McNeill Whistler*, exh. cat. (New Haven: Published in association with the Art Gallery of Ontario by Yale University Press, 1984), 138.

12. Philip Gilbert Hamerton, *Etching and Etchers* (London: Macmillan, 1868), 28, 29.

13. Frederick Wedmore, "My Few Things," *Art Journal* 46 (January 1894): 7.

14. Frederick Keppel, "Modern Disciples of Rembrandt," *Art Review* 2 (September–November 1887): 149. Keppel handled English etchings, including the work of Haden and Whistler, and was a personal friend of Haden and Goulding.

15. Frederick Wedmore, "The Royal Society of Painter-Etchers," *Studio* 5 (April–September 1895): 22–26.

16. Atlas [Edmund Yates], "What the World Says," *The World: A Journal for Men and Women* 336, vol. 13 (December 8, 1880): 9–13. Whistler replied to this comment in *The World* 339, vol. 13 (December 29, 1880): 12: "An etching does not depend, for its importance, upon its size. I am not arguing with you—I am telling you."

17. William John Loftie, *A Plea for Art in the House* (London: Macmillan, 1876), 64.

18. Hamerton, "Modern Etching in France," 70.

19. Philip Gilbert Hamerton, "Mr. Seymour Haden's Etchings," *Scribner's Monthly* 20 (1880): 590. In this same article, Hamerton offered his rebuttal to Ruskin's statement that etching was "an indolent and blundering art." The former argued that "having a free instrument . . . [the artist] is expected to put all the more knowledge and intelligence into his drawing" (587).

20. Haden, *About Etching*, 18–20.

21. Hamerton, *Etching and Etchers*, 60–62.

22. F. T. Palgrave, "Mr. Seymour Haden's Etchings," *Fine Arts Quarterly Review*, n.s., 2 (1867): 121, 135.

23. Translated either as "the sweet success of labor" or as "o sweet solace of toil," the verse appearing in the print is from Horace's first *Ode*.

24. Hamerton, *Etching and Etchers*, 42.

25. Palgrave, "Mr. Seymour Haden's Etchings," 134. In 1910 Martin Hardie recalled, "Like the Pre-Raphaelites, the pioneers of etching were fighting against the deadness of ideals . . . of the age." Martin Hardie, *Frederick Goulding: Master Printer of Copper Plates* (Stirling: Eneas Mackay, 1910), 151.

26. Frederick Wedmore, "Mr. Seymour Haden's Etchings," *Art Journal* 34 (June 1882): 164.

27. Frederick Wedmore, "Francis Seymour Haden by W. Strang," in *English Etchings: Thirty Original Etchings by English Artists and Essays Relating to the Art* (London: Samson Low, Marston, Searle and Rivington, 1888), 8.

28. Keppel, "Modern Disciples of Rembrandt," 145.

29. Haden's writings on Rembrandt include *Catalogue of the Etched Work of Rembrandt, Selected for Exhibition at the Burlington Fine Arts Club* (London, 1877) and *The Etched Work of Rembrandt, True and False: A Lecture Delivered in the Gallery of the Royal Society of Painter-Etchers* (London, 1895).

30. "Minor Topics of the Month," *Art Journal* 6 (April 1867): 114.

31. Alfred Whitman, *The Print-Collector's Handbook* (London: G. Bell, 1902), 19.

32. Large reproductive engravings were often as expensive, or more expensive, than original etchings for much of the Victorian period. See Martha Tedeschi, "How Prints Work: Reproductions, Originals, and Their Markets in England" (PhD diss., Northwestern University, 1994); and Pat Gilmour, "On Originality," *Print Quarterly* 23, no. 1 (March 2008): 36–50. For further discussion of class distinction based on ownership, see Rémy G. Saisselin, *The Bourgeois and the Bibelot* (New Brunswick, NJ: Rutgers University Press, 1984), esp. 174.

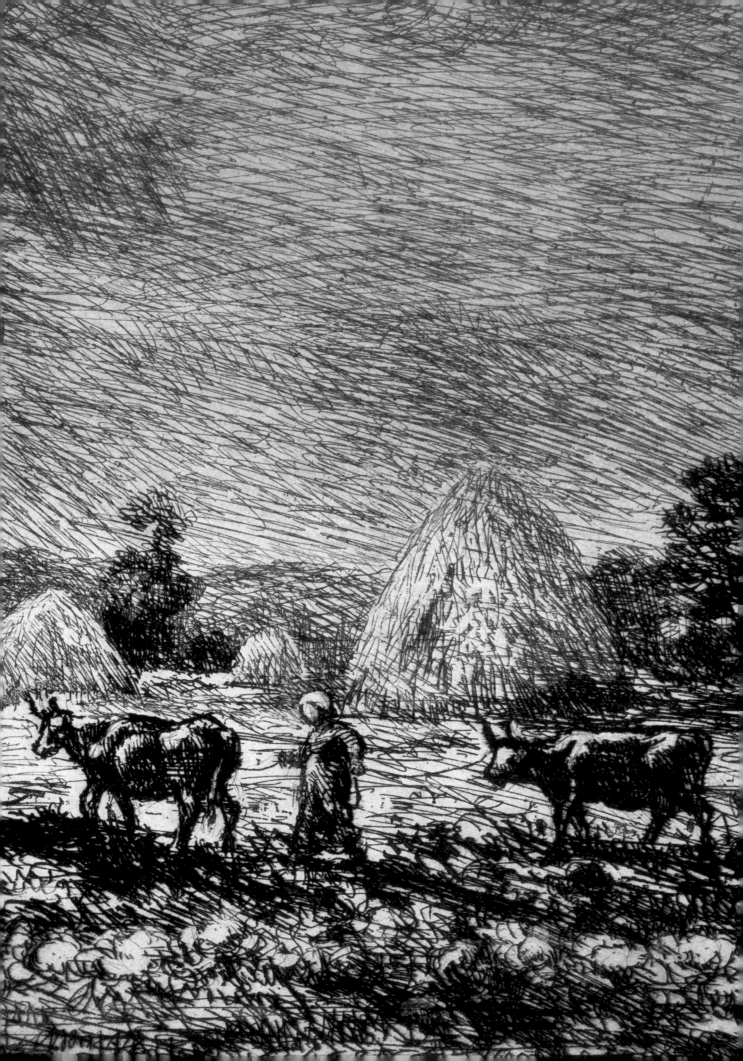

ANNA ARNAR

Seduced by the Etcher's Needle: French Writers and the Graphic Arts in Nineteenth-Century France

I N 1862 ALPHONSE CADART, one of the instrumental figures behind the French etching revival, launched the publication *Eaux-fortes modernes: Publication d'oeuvres originales et inédites.* In promoting his new venture of selling contemporary etchings, Cadart recognized the strategic value of art criticism. He engaged well-known literati—including Théophile Gautier, Jules Janin, Théophile Thoré, and Jules Castagnary—to write a compelling preface for each issue. These texts were supplemented by contributions to Cadart's ancillary publication *L'union des arts: Nouvelles des beaux-arts, des lettres, et des théâtres* by renowned writers such as the poet Théodore de Banville and the critic Philippe Burty. Burty, who had devoted himself to writing reviews of prints displayed at the Salon for the *Gazette des beaux-arts*, played a key role in promoting the virtues of etching to a general audience.[1] He codified the sketchlike qualities of the etching medium and its painterly inking "cuisines" while celebrating its unparalleled expressive potential.

The present essay will examine some of the seductive language and mythologies that French men of letters at mid-century devoted to etching and the figure of the printmaker.[2] Such an examination suggests a parallel between the free and fluid expression identified in contemporary etching and some of the entrepreneurial strategies Cadart and printmakers themselves employed to develop new markets in art. In other words, new terrains of artistic expression seemed to open up new terrains of opportunity. Moreover, the marginal status of the print compared to that of painting, coupled with its raw expressive poten-

tial, appealed to writers attempting to articulate the unique conditions of modern artistic production that emerged in France during the Second Empire. The etching revival thrived on the mythic constructions of the graphic artist, whose idiosyncratic mark-making was celebrated as a stamp of authenticity but also as a record of intense physical activity. Although etchings were characterized as fluid and spontaneous, French writers were eager to insist on the difficulty and depth of commitment needed to execute them. Etching is, as Charles Baudelaire reminds his readers: "like all great art, very complex beneath its apparent simplicity, it requires prolonged devotion to be brought to perfection."[3] As we shall see, French men of letters, including Baudelaire, also exaggerated the mental and physical exertion required for the etching process. That such descriptions are largely absent from British criticism of the time calls attention to some important distinctions between French and British modernism.

On a rudimentary level, French writers of the mid-nineteenth century were drawn to printmakers by virtue of resemblance. The graphic artist and writer were laborers in black and white, sharing the basic tools of the trade: paper and ink. The manual gestures of the etcher in particular offered striking parallels with the craft of writing (see Tedeschi, p. 25). Moreover, writers and etchers often treaded the precarious line between private production and public consumption; both frequently labored in solitude, but since their medium was print, they could potentially multiply and diffuse their work. Cadart's supporters seized on these fundamental similarities, often likening the etched image to the printed text. As Thoré wrote in the

FIGURE 37
Augustin-Théodule Ribot
The Peelers, 1863
Etching
27.9 x 20 cm, plate
Minneapolis Institute of Arts, The
William M. Ladd Collection, Gift of
Herschel V. Jones, 1916

preface to the third issue of *Eaux-fortes modernes*, "Compared to drawing, etching is the analogue of printing and the press, which multiply written thought."[4] Castagnary made a similar observation in his preface a year later: etching is a "spontaneous art like writing and powerful like printing, which makes the painter confide his thought directly to metal and which like writing can multiply copies infinitely."[5] Repeatedly, writers and critics compared etchers to "poets" and etching to a "spoken literature" (Thoré), "a captured notation" (Banville), or an "individual thought" (Castagnary).

Another important quality of etching, promoted in essays in *Eaux-fortes modernes* and in critical assessments of the publication, was its non-official status. It is an art form commonly viewed in private contexts—or, as Banville proclaimed, an "art enjoyed by the fire."[6] As such, etching was frequently characterized as being free from academic and institutional restraints and thus inherently more honest and closer to the modern creative ethos than officially sanctioned art. While this kind of rhetoric is not surprising, a theme that has not been acknowledged in the scholarship on etching is that many literary figures further emphasized printmaking's outsider status by conjuring images of illicit and dangerous behavior. For instance, Banville claimed that Augustin-Théodule Ribot's "mysterious cooks" act as if they are "committing crimes" (Figure 37) and characterized the etcher Bracquemond as a cavalier swashbuckler whose images are delicate yet betray a

certain "violence" (see Morehead, Figure 49).[7] Baudelaire, in his famous essay defending Cadart's publication, warned suggestively, "one must not forget that etching is a profound and dangerous art."[8] Such descriptions were, of course, dramatically exaggerated, but they served to create an image of the printmaker as spontaneous and free from the confines of traditional art practice.

The mythic qualities of the printmaker had an extended literary legacy in France: Gautier's essays on Rodolphe Töpffer and on Goya (1842 and 1856), Jules Champfleury's short story based on the printmaker Rodolphe Bresdin entitled *Chien-Caillou* (1845), and the Goncourt brothers' novel *Manette Salomon* (1865), to name but a few.[9] This body of literary texts extolling the image of the graphic artist is important, for it suggests a more complex and symbiotic relationship between printmaking and literature. As an art of paper and ink, etching provided a powerful model of graphic writing that encompassed both physical immediacy and the mobility central to the construction of modernity.

In the literature and criticism devoted to etching, the most revealing parallel between writing and etching is found in the vivid descriptions of an etcher's style of mark-making as a type of writing (*écriture*) or even more tellingly as *griffonnages* and *gribouillage* ("scribbles" and "illegible scrawl"). Men of letters commonly used these terms to evoke vigorous or highly idiosyncratic graphic marks, as found in Baudelaire's commentary on the etcher Jongkind:

Mr. Jongkind, the charming and candid Dutch painter, has turned out some plates on which he has confided the secret of his memories and dreams, calm like the banks of the great rivers and and the horizons of his noble homeland, –singular abbreviations of his painting, sketches that all amateurs, accustomed to deciphering the soul of an artist in his most rapid scribbles, will know how to read.[10]

Baudelaire described Jongkind's prints as pages from a personal diary: the artist "confides" his secrets, and seasoned amateurs can "decipher" and "read" his rapid scribbles.

Similarly, in his short story *Chien-Caillou*, Champfleury articulated a certain legibility in the unique handwriting of Bresdin (camouflaged here as Chien-Caillou) and confirmed that only true artists or connoisseurs could "read" his works.[11] Furthermore, Champfleury portrayed Chien-

Caillou's scheming dealer, Père Samuel, as exploiting this language of selective legibility:

Père Samuel knew many amateurs; he brought some etchings to a few of them who responded with what Diderot had said about the pen drawings of Rembrandt: I do not understand anything in these scribbles. But an old print collector, more discerning, let out a cry of admiration at the sight of these drawings and asked for the name of the author.[12]

Champfleury's reference to Denis Diderot is useful because it demonstrates the greater emphasis some nineteenth-century writers and critics placed on the degree of personal legibility.[13] To Diderot, Rembrandt's "scribbles" were part of a mysterious language of the past; they may warrant admiration, but they defy comprehension. In contrast, Champfleury and Baudelaire evoked notions of legibility in the work of contemporary printmakers. But they did not insist on universal legibility; rather, they called for a highly subjective and personal legibility that embodied a certain authenticity and vigor.

Baudelaire developed this idea of selective legibility further in his essay "The Painter of Modern Life" (1863), in which he defended the draftsman and illustrator Constantin Guys from the accusation that his works were "formless drawings":

Thus, Mr. G[uys], faithfully translating his own impressions, marks with an instinctive energy the culminating or luminous points of an object . . . ; and the imagination of the spectator, enduring this very despotic mnemonic, sees with clarity the impression produced by things on the mind of M. G. The spectator is here the translator of a translation that is always clear and euphoric.[14]

Baudelaire did not attribute the clarity of Guys's images to his imitative skills but to his distinctive and emphatic graphic marks. In other words, it is the personality of the artist and his subjective experiences that become legible in an image rather than the subject depicted.

The increased emphasis on personality seen in Baudelaire's and Champfleury's texts parallels the nineteenth-century development of the word *griffe* or *griffoni* (from which the word *griffonnage* derives) to describe the distinctive marks of the printmaker. In addition to its

common meaning as "claw" or signature stamp, *griffe* assumed the specific meaning of "a mark of personality" or a visual trademark of sorts.[15] Théophile Gautier, for instance, identified this characteristic in the work of Goya, stating that Goya's "mark of a lion" features "even in the vaguest of sketches."[16] In the first issue of *Eaux-fortes modernes*, Gautier extended this analogy by arguing that the etching revival was not concerned with a particular style, method, or subject but with personalities: "It doesn't matter! Everything is good as long as it has meaning and displays in some corner the mark of a lion."[17]

For contemporary commentators, the artist's *griffe* was not only an authentic indicator of talent but a visible testimony to the process of artistic labor. Writers as ideologically diverse as Baudelaire, Champfleury, and the Goncourt brothers described this process as necessarily difficult and even violent, for this image captured what they viewed as the intense physicality of modern artistic production. Whereas etching in the eighteenth-century amateur tradition was stereotypically regarded as spontaneous and accessible,[18] modern etchings were described as the product of great bodily strain and struggle despite their appearance of spontaneity and ease. In *Chien-Caillou*, for instance, the etcher not only lives in abject poverty but suffers the physical and creative challenges of etching. Champfleury wrote that Chien-Caillou's tool had never encountered "so many difficulties" and that the artist's entire being was invested in the process: "During this work, the face of the etcher lit up with a splendid grimace that proved that his work was not all material and that his thoughts passed to his burin. He worked in this manner for four hours."[19] Other prints by Chien-Caillou required as much as three days of work.[20]

Champfleury's Chien-Caillou is an inspired writer whose intense artistic labor transports him beyond the bounds of time and space. In *Manette Salomon*, Edmond and Jules Goncourt similarly described the physical strain elicited by the complete absorption of the etcher:

> Etching seized him with its interest, its passionate absorption, the escape it provided from everything, the kind of erasure of time it created in his life. Bent over his plate, rubbing the copper, to discover under the cutting and the scratching, the red gold line in the black varnish, he let days go by. And it was like a momentary

suspension of his life, this subtle cerebral daze, this type of congestion that made his eyes weary, this emptiness that he felt in his brain in the place of sadness.[21]

Contemporary portraits of printmakers also emphasized the physical demands of their labor. On a fundamental level, these images suggest a writer at work, since printmakers were conventionally portrayed hunched over a table or desk, as in François Bonvin's *The Etcher by Lamplight* (Figure 38) and the portrait *Rops Etching* (Figure 39). While these images play on traditional portraits of artists in their studios, the focus on the printmaker's slumped posture and the solitary, physical nature of the work provides a stark contrast to the portrayals of aristocratic or amateur etchers—especially fashionable female etchers from the previous century.[22] The mythic treatment of physical strain and implied violence in nineteenth-century literary accounts and portraits removed etching from any socially polite or feminine context.

As Walter Benjamin has noted, Baudelaire echoed the theme of solitary struggle in "Le soleil" from *Les fleurs du mal*,[23] written in the voice of the toiling poet:

> Je vais m'exercer seul à ma fantasque escrime,
> Flairant dans tous les coins les hasards de la rime,
> Trébuchant sur les mots comme sur les pavés,
> Heurtant parfois des vers depuis longtemps rêvés.

> I venture out alone to drill myself
> In what must seem an eerie fencing-match,
> Dueling in dark corners for a rhyme
> And stumbling over words like cobblestones
> where now and then realities collide
> with lines I dreamed of writing long ago.[24]

Baudelaire's poet is engaged in a private fencing match whose physical effort is underscored in the original French text with words such as *flairant* (literally, "sniffing out"), *trébuchant* ("stumbling"), and *heurtant* ("colliding"). The struggle of artistic production, Benjamin argued, is necessary in order to confront the violent tensions of modern life.[25] It also provides vivid testimony of the paradoxical position of the artist, since the creative act serves the interests of a social order that the "solitary" artist tries to evade.[26]

Benjamin observed that "Le soleil" contains one of Baudelaire's only descriptions of poetic labor. In light of

FIGURE 38
François Bonvin
The Etcher by Lamplight, 1861
Etching with drypoint
21.9 x 16.4 cm, plate; 27.5 x 21 cm, sheet
The Art Institute of Chicago, Gift of Douglas Druick, 1991.917

FIGURE 39
Félicien Rops and F. Taelemans
Rops Etching, 1896 or earlier
Etching
9.4 x 7 cm
Photograph: University of Chicago Library

this fact, it is noteworthy that Baudelaire devoted far more attention to describing the labor of the graphic artist, examining the work of a range of printmakers and illustrators including Charles Meryon, Honoré Daumier, Paul Gavarni, J. J. Grandville, Joseph Traviès, and a host of etchers associated with Cadart.[27] Indeed, the only time Baudelaire ever publicly wrote about his friend Édouard Manet was in the context of etching rather than painting. After complaining about the mediocrity of French academic painting, Baudelaire singled out the etchings of Manet and Alphonse Legros (see Skipwith, Figure 55) for praise. According to Baudelaire, these two artists "unite with a distinct taste for reality, modern reality—which is already a good symptom—this vivid and ample imagination, sensitive, audacious, without which, one must admit, all the best skills are but servants without masters, agents without a government."[28] Baudelaire was therefore drawn to the graphic arts not only for their hybrid status as a kind of pictorial writing requiring great bodily and creative investment, but also because they offered the most appropriate conduits for the modern imagination, which must be free and self-governing.

The materiality of the graphic artist's mark making was thus viewed by many French writers as a virtue; inscribed in the calligraphic gesture of the *griffe* were the signs of freedom—freedom from artistic conventions but also from academic, social, and institutional restraints. In keeping with this image of freedom, Champfleury extolled Chien-Caillou as an autodidact—a self-taught artist who had lived on the streets from the age of ten "without literary education, without artistic education."[29] His modest origins also serve to enhance his outsider status. He grows up as a son of a tanner in the seamy suburb of the Faubourg Saint-Marceau. After fleeing his father's beatings, he settles in Paris in one of the poorer neighborhoods by the Place Maubert, where, Champfleury noted, "one frequently goes hungry."[30] This neighborhood was reputed for its riots and population of social derelicts and petty criminals. By playing up Chien-Caillou's indecorous setting, Champfleury separated him from the polite milieu of the well-bred genteel artist.

Nineteenth-century graphic artists were further idealized as liberated outsiders for the manner in which their imagery was disseminated and collected. Chien-Caillou

does not display his work in officially sanctioned or public fine art venues; rather, it circulates in a semi-private manner among a few select amateurs, like-minded artists, and literati. Chien-Caillou's prints are procured only through his dealer Père Samuel, who personally pays visits to potential buyers; this vulnerable dependence upon his dealer (who is characteristically portrayed as a shady exploiter) inspires the printmaker to envision selling his work independently:

> When I have gathered some coins, which will not be long, I will buy some used plates and make myself a small boat. Inside I'll put potatoes, a bag of bread for supplies, some carrots and bran for my pet rabbit, and then everything that I need for etching. We will go to Belgium, to Holland, and everywhere there are paintings of Rembrandt.... While we are in the middle of the water, I will etch. I will also have some savings to restock my provisions.... Besides, I will sell some of my prints, I know some very wealthy collectors in Belgium. This is a dream I have had all my life.[31]

It is telling that Chien-Caillou's vision of greater financial independence lies outside of France, with its strong traditional artistic hierarchies and institutions. In contrast, Holland and Belgium held the promise of a broader and more generous patronage base. Significantly, Chien-Caillou proposes to access this new terrain of patrons and collectors with the aid of a special boat. This vessel is the ultimate symbol of independence since it simultaneously serves as transportation and as studio space, allowing for a self-sustaining system of selling and disseminating artwork. The boat literally embodies freedom, providing mobility and a sense of control, since the artist seemingly navigates his own destiny.

In Champfleury's fictional tale, Chien-Caillou never lives out his dream as boatman-etcher-trader. But about a decade after the story was published, in 1857, Charles-François Daubigny managed to build and launch a studio-boat known as *Le Botin*.[32] Daubigny personified the self-sufficient and free artist. For days at a time, he would live and work on *Le Botin*; the records of this experience were published with Cadart as a portfolio of etchings titled *Voyage en bateau: Croquis à l'eau-forte (The Boat Trip: Etched Sketches)* in 1862. In one print from the series (Figure 40), Daubigny visually catalogues his survival gear:

FIGURE 40
Charles-François Daubigny
The Boat Studio, from *The Boat Trip*, 1862
Etching
13 x 17.7 cm, plate; 22 x 29.9 cm, sheet
The Art Institute of Chicago, The Charles Deering Collection, 1927.2633a

cookware, food provisions, wine, blankets, a lamp, canvases, notebooks, brushes, and pencils.[33] In these loose calligraphic images typical of Cadart's stable of etchers, we also witness the comical and adventurous spirit of Daubigny and his companions as they sketch, fish, eat, and overcome challenges of living and working on the river (Figure 41).

Although Daubigny was a relatively successful artist who had shown his works at the Salon, he was frequently portrayed and perceived as an outsider, and his river trav-

els enhanced this bohemian image. Frédéric Henriet, Daubigny's friend and biographer, compared the artist to popular adventure heroes and even to Chien-Caillou himself (whose name in turn was based on James Fenimore Cooper's character Chingachgook from *The Last of the Mohicans*): "Thus they lived on the river, abruptly separated from social life, alone in the middle of nature's silent serenities, industrious and free, like the popular heroes of Camp and DeFoe, living out the long-cherished dream of Champfleury's Chien-Caillou."[34] This lively description

FIGURE 41
Charles-François Daubigny
Swallowing (Meal on the Boat), from *The Boat Trip*, 1862
Etching
13 x 17.2 cm, plate; 21.7 x 28.7 cm, sheet
The Art Institute of Chicago, The Charles Deering Collection, 1927.2633b

embodies the central myths surrounding the artist-etcher. *Le Botin* provided "abrupt separation" from the social and economic confines of urban life. In the same text, Henriet even prescribed leaving the city as a means to boost creativity: "It's time to pack away in the armoire the black suit of social concessions; it's time to forget for six months the auction house and official salons, and the art dealer and the collector. . . . The hour of departure has arrived!"[35] On his boat, Daubigny navigated freely along the Seine and Oise rivers that provided him a variety of motifs and, above all, symbolic independence from the pressures of the urban art world, such as one sees also in his choice of pastoral subjects (Figure 42).

True to the image of the laboring etcher, Henriet made clear that boating was not simply a pleasure cruise: Daubigny and his companions were "industrious" as well as "free." Henriet continually emphasized the bodily struggles embedded in the artistic process, even deploying Baudelaire's fencing metaphor. In another passage, he portrayed artists in intensive trance-like states, "throwing themselves" into their work.[36] The fact that Henriet, whose text is largely devoted to plein air painting, taps into the literary language devoted to printmaking, particularly etching, suggests provocative links between the values promoted in printmaking and painting. Like the outsider graphic artists Chien-Caillou and Guys, Henriet's plein air

47

CLAIR DE LUNE À VALMONDOIS.

FIGURE 42
Charles-François Daubigny
Full Moon at Valmondois, 1877
Etching
Cat. 11

painters are quasi-subversive and even "dangerous."[37] Henriet referred to the rural farmer as a kind of "plein air worker" and noted that the laborer of the land and the painter of the land inherently share similar political ideologies: "They are linked by the solidarity of their smocks (*blouses*)."[38]

Boating and enjoying the pleasures of the countryside were, of course, primary activities closely identified with the bourgeois city dweller, and therefore Henriet was careful to distinguish his plein air painter: "A purebred landscape artist does not possess any of the elegant manners of the tourist. Seeing him on the great path, with a pack on his back and stick in hand, one thinks of a hawker of cheap novels or Epinal prints."[39] Just as Henriet compared Daubigny to popular adventure heroes, he similarly billed the plein air painter as rugged, adventurous, and politically charged: he is a nomad, a peddler, an unconventional yet

determined entrepreneur. One need only look at the accompanying illustration to Henriet's book for this charged image (Figure 43). Two painters are seated on the ground, their faces obscured by their broad-brimmed hats. One of them turns to the side, partially revealing rugged facial hair and his worker's *blouse*; with painter's tools at his side, he smokes and looks off in the distance.

Perhaps the best embodiment of the ideals sustained by French writers about the rough-hewn and untrained outsider artist is Charles Meryon (Figure 44). Meryon served as a naval officer for several years, traveling extensively and making numerous sketches on these travels. Like Chien-Caillou and Guys, Meryon was largely self-taught and was surprisingly ignorant of past and present art.[40] Also like Chien-Caillou (and Bresdin himself), Meryon was known to be a loner, possessing a volatile temperament. His instability forced him to spend

FIGURE 43

A. Portier after Léon Loire

The Landscapists, 1866 or earlier

Etching

11 x 14 cm, plate

Photograph: University of Chicago Library, Special Collections Research Center

time in mental health clinics, where he lived out his final days.[41]

For admiring men of letters, the state of madness was crucial to establishing Meryon's outsider status. His etchings were no mere observations of nature, but hallucinations. Victor Hugo, a notable etcher himself, declared Meryon's prints to be "visions"; Baudelaire found that Meryon possessed a "pungent" and singular "poetic" vision.[42] Burty placed his originality "far above the reach of everybody."[43]

The bulk of Meryon's reputation rested on his series *Eaux-fortes sur Paris* (1852, with subsequent printings)

which reinforces his identity as boatman and navigator. Not only did Meryon largely concentrate on scenes along the Seine and its waterways and bridges (Figures 45–47), but he dedicated the suite to the seventeenth-century Dutch etcher Reynier Nooms, known as the "Zeeman" ("seaman"). The dedication to Zeeman (referred to by Meryon as "master and sailor") includes a reference to the "symbolic" coat of arms for the city of Paris, which consists of a great ship encircled by olive and oak branches and crowned with fleurs-de-lis and the architectural forms of Paris itself (Figure 48). A portion of this dedication reads as follows:

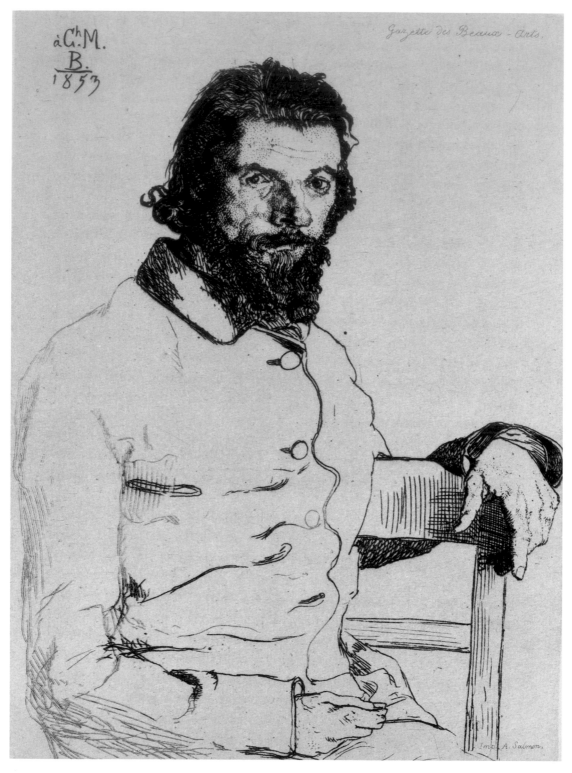

FIGURE 44

Félix Bracquemond

Portrait of Charles Meryon, 1853, repr. 1884

Heliogravure etching

19.7 x 14.3 cm, plate; 26.4 x 16.2 cm, sheet

Smart Museum of Art, Gift of Brenda F. and Joseph V. Smith, 2003.32

FIGURE 45
Charles Meryon
The Arch of the Notre-Dume Bridge, Paris, 1853
Etching and drypoint
15.1 x 19.1 cm, plate; 21.3 x 24.2 cm, sheet
The Art Institute of Chicago, Bequest of Harold R. Warner, 1939.2070

J'espère en un autre âge
Naviguant dans tes eaux,
Revoir encore la plage,
La mer et les vaisseaux;
Pour d'une pointe avide,
Dans le cuivre graver
Par le mordant acide,
Tout ce qu'en mon penser
Je vois de grand, d'utile,
En l'élément marin;
Toi, mon cher chef de file
Tu me tendras la main!

De ce premier ouvrage
Où j'ai gravé Paris,
La ville à la galère
Qu'à ton instar je fis

En ta simple manière,
Accepte au moins l'hommage!

Mon maitre et matelot,
Reinier toi que j'aime
Comme un autre moi-même
Au revoir, à bientôt!

In some new age may I,
As through thy waters slipping,
Once more thy shores descry,
Thy ocean and thy shipping;
That on the plate well laid,
With keen point I may trace,
By acid's mordant aid,
All, in my thought's vast space,

BAIN·FROID CHEVRIER
DIT DE L'ÉCOLE

FIGURE 46
Charles Meryon
The Pont-au-Change, 1854
Etching
15.4 x 33 cm, plate;
20.7 x 38.4 cm, sheet
The Art Institute of Chicago,
Elizabeth Hammond Stickney
Collection, 1909.277

FIGURE 47
Charles Meryon
Chevrier's Cold Bath, 1864
Etching
Cat. 29

I see that's good and great
In the salt brine of the sea;
And thou, dear captain and mate,
Wilt offer thy hand to me!

Of this first work and new,
Where I have Paris shown,
—A ship adorns her banner—
And tried to make my own
My master's simple manner,
Accept the homage due!

My master and man of the sea,
Reynier, thou whom I love
Like another part of me,
May I see thee soon above![44]

Here, Meryon aligns the act of etching to sailing at sea. Like a boat with no moorings, Meryon navigates the city of Paris with the same freedom as Baudelaire's philosophical idler Constantin Guys. And yet, Meryon pushes the concept of freedom even further by linking the sailor's voyage to life itself. At the end of his etching-voyage, Meryon quite explicitly implies that he will soon attain the ultimate form of freedom: death. Much to the astonishment of his literary supporters like Baudelaire, this death was so complete that it would include obliterating his etchings. In addition to destroying his plates to the precious *Eaux-fortes sur Paris* after their second printing, Meryon shunned most efforts to promote his work, deeming them to be part of some sort of nefarious plot.[45] Although his reactions were attributed to a form of paranoia, his deliberate thwarting of success could be interpreted as carrying out the idealization of the graphic artist's freedom to its extreme conclusion.

FIGURE 48
Charles Meryon
Arms Symbolic of the City of Paris, 1854
Etching
13.5 x 11.2 cm, plate; 43.9 x 32 cm, sheet
The Art Institute of Chicago, Clarence Buckingham Collection, 1938.1619

NOTES

All translations are by the author unless otherwise noted.

1. Burty continued to work with Cadart through the 1870s and wrote many of the prefaces to the annual series *L'eau-forte en 1874–1881*.

2. Portions of this essay are based on the third chapter of my forthcoming book *The Book as Instrument: Stéphane Mallarmé, the Artist's Book, and the Transformation of Print Culture* (Chicago: University of Chicago Press).

3. "[C]omme tout grand art, très compliqué sous sa simplicité apparente, il a besoin d'un long dévouement pour être mené à perfection." Charles Baudelaire, "Peintres et aquafortistes," in *Oeuvres complètes*, ed. Claude Pichois (Paris: Gallimard, 1976), 2:739.

4. "Relativement au dessin, l'eau-forte est l'analogue de l'imprimerie et de la presse, qui multiplient la pensée écrite." Théophile Thoré [W. Burger], "Société des Aquafortistes: Préface, Troisième année," cited in Janine Bailly-Herzberg, *L'eau-forte de peintre au dix-neuvième siècle: La Société des Aquafortistes, 1862–1867* (Paris: Léonce Laget, 1972), 1:271.

5. "[A]rt spontané comme l'écriture et puissant comme l'imprimerie, qui fait que le peintre confie directement sa pensée au métal et qui comme l'écriture en peut multiplier à l'infini les exemplaires." Jules Castagnary, "Société des Aquafortistes: Préface, Quatrième année," cited in Bailly-Herzberg, *L'eau-forte de peintre*, 1:274.

6. "[L]'art du coin du feu." Théodore de Banville, "La Société des Aqua-fortistes," *L'union des arts* (October 1, 1864), reprinted in Bailly-Herzberg, *L'eau-forte de peintre*, 1:129.

7. "Ribot avec ses cuisiniers mystérieux comme s'ils faisaient des crimes"; Bracquemond "un très jeune homme à l'oeil vif et chercheur aux épais cheveux noirs en brosse, à la barbe fine et légère, svelte et bâti en capitaine d'aventures du seizième siècle. . . . [S]a *Fuite en Egypte*, gribouillée avec la violence de l'inspiration." Ibid.

8. "[I]l ne faut pas oublier que l'eau-forte est un art profond et dangereux." Charles Baudelaire, "Peintres et aquafortistes," in *Oeuvres complètes*, 2:739.

9. *Chien-Caillou* underwent numerous reprints throughout the nineteenth century.

10. "M. Jongkind, le charmant et candide peintre hollandais, a déposé quelques planches auxquelles il a confié le secret de ses souvenirs et de ses rêveries, calmes comme les berges des grandes fleuves et les horizons de sa noble patrie,—singulières abréviations de sa peinture, croquis que sauront lire tous les amateurs habitués à déchiffrer l'âme d'un artiste dans ses plus rapides *gribouillages*." Baudelaire, "Peintres et aquafortistes," in *Oeuvres complètes*, 2:740.

11. "Pour comprendre les eaux-fortes de Chien-Caillou, il fallait être artiste. La plupart des gens n'y auraient rien vu; les véritables amis de l'art y découvrait un monde. Jamais la pointe ne s'était jouée d'autant de difficultés." Jules Champfleury, *Chien-Caillou: Fantaisies d'hiver* (Paris: Éditions des Cendres, 1988), 41.

12. "Le Père Samuel connaissait beaucoup d'amateurs: il porta les eaux-fortes chez quelques-uns qui répondirent ce que Diderot disait des dessins à la plume de Rembrandt: Je ne comprends rien à ces griffonnages. Mais un vieux collectionneur d'estampes, mieux avisé, poussa un cri d'admiration à la vue de ces dessins et demanda le nom de l'auteur." Ibid.

13. Baudelaire also made reference to Diderot's use of the term *gribouillage* (rather than *griffonnage*): "Gribouillages est le terme dont se servait un peu légèrement le brave Diderot pour caractériser les eaux-fortes de Rembrandt." Baudelaire, "Peintres et aquafortistes," in *Oeuvres complètes*, 2:740. Diderot wrote on Rembrandt in *Voyage en Hollande* (1773).

14. "Ainsi, M. G., traduisant fidèlement ses propres impressions, marque avec une énergie instinctive les points culminants ou lumineux d'un objet . . . ; et l'imagination du spectateur, subissant à son tour cette mnémonique si despotique, voit avec netteté l'impression produite par les choses sur l'esprit de M. G. Le spectateur est ici le traducteur d'une traduction toujours claire et enivrante." Baudelaire, "Le peintre de la vie moderne," in *Oeuvres complètes*, 2:698.

15. Bourdieu speaks of the "magie de la griffe" in the context of fashion design—the *griffe* or mark of the designer is what gives symbolic and economic value to an article of clothing, perfume, shoes, and so on. It is not the object per se that is valued but the "mark of authenticity." Although he does not investigate the origin of the term *griffe*, he does make the analogy between the fashion industry and the art world: "ce qui fait la valeur de l'oeuvre, ce n'est pas la rareté (l'unicité) du produit mais la rareté du producteur, manifestée par la signature, équivalent de la griffe." ("what makes the value of a work is not the rarity (the singularity) of the product but the rarity of the producer, manifest in the signature, equivalent to the mark.") Pierre Bourdieu, *Questions de sociologie* (Paris: Éditions de Minuit, 1980), 219–20.

16. "[L]a griffe du lion raye toujours ses dessins les plus abandonnés." Théophile Gautier, "Francesco Goya Y Lucientes," *Cabinet de l'amateur* 1 (1842): 558. He also used this term to describe Célestin Nanteuil's etchings.

17. "Il n'importe! tout est bien qui signifie quelque chose, et montre dans un coin la griffe du lion." Théophile Gautier, "Société des Aquafortistes: Préface, Première année: Un mot sur l'eau-forte" (August 1863), cited in Bailly-Herzberg, *L'eau-forte de peintre*, 1:267.

18. Victor Carlson, "The Painter-Etcher: The Role of the Original Printmaker," in *Regency to Empire: French Printmaking, 1715–1814*, exh. cat., ed. Victor Carlson and John W. Ittmann (Minneapolis: Minneapolis Institute of Arts, 1984), 26.

19. "Jamais la pointe ne s'était jouée d'autant de difficultés"; "Pendant ce travail, la figure du graveur s'illumina d'une grimace splendide qui prouvait que son travail n'était pas tout matériel et que sa pensée passait dans son burin. Il travailla ainsi quatre heures." Champfleury, *Chien-Caillou*, 41, 25. The term *graveur* means both "engraver" and "etcher." Champfleury is not always consistent with his printmaking vocabulary; he refers to Chien-Caillou's prints throughout as etchings or drawings, but for tools, he uses the words "burin," *aiguille* (needle), and *la pointe* (tip of a pen or needle).

20. Chien Caillou declares to his stingy dealer Père Samuel: "Voilà trois jours que je travaille là-dessus." Ibid., 40.

21. "L'eau-forte l'empoignait avec son intérêt, son absorption passionnée, l'oubli qu'elle lui donnait du tout, l'espèce d'effacement du temps qu'elle faisait dans sa vie. Penché sur sa planche, à frotter le cuivre, à découvrir, sous les tailles et les égratinures, l'or rouge du trait dans le vernis noir, il passait des journées. Et c'était comme une suspension momentanée de sa vie, que ce doux hébètement cérébral, cette espèce de congestion qu'amenait en lui la fatigue des yeux, ce vide qu'il se sentait dans le cerveau à la place du chagrin." Edmond and Jules Goncourt, *Manette Salomon* (Paris: Ernest Flammarion/Eugène Fasquelle, [1925?]), 380.

22. One thinks, for example, of Madame de Pompadour, who was taught to etch by François Boucher. Moreover, etching was taken up by numerous eighteenth-century amateurs, collectors, and court elites, including the comte de Caylus, the abbé de Saint-Non, Ch. H. Watelet, La Live de Jully, and even Louis-Philippe, duc d'Orléans (father of King Louis-Philippe). See George Leventine, "French Eighteenth-Century Printmaking in Search of Cultural Assertion," in Carlson and Ittmann, *Regency to Empire*, 10–11.

23. Walter Benjamin, *Charles Baudelaire: A Lyric Poet in the Era of High Capitalism* (London: New Left Books, 1977).

24. Charles Baudelaire, "Le soleil," in *Les fleurs du mal*, tr. Richard Howard (Boston: David R. Godine, 1982), 88.

25. For a particularly compelling analysis of Benjamin's understanding of modernity as a "shock" to the senses, see Susan Buck-Morss, "Aesthetics and Anaesthetics: Walter Benjamin's Artwork Essay Reconsidered," *October* 61 (Fall 1992): esp. 16–17.

26. Benjamin, *Charles Baudelaire*, esp. 68, 75. Roland Barthes also speaks of the issue of labor and work as a central feature in modern literature. In the nineteenth century, he observes, "toute une classe d'écrivains soucieux d'assumer à fond la responsibilité de la tradition va substituer à la valeur-usage de l'écriture, une valeur-travail. L'écriture sera sauvée non pas en vertu de sa destination mais grâce au travail qu'elle aura coûté." ("an entire group of writers anxious to fully take on the responsibility of tradition will substitute use-value of writing with work-value. Writing will not be saved by virtue of its destination, but by the work it will have cost.") Roland Barthes, *Le degré zéro de l'écriture* (Paris: Éditions du Seuil, 1953), 46.

27. Baudelaire's first essay on etching was entitled "L'eau-forte est à la mode" and appeared in *La revue anecdotique* in April 1862. The second essay, which was largely based on the first but substantially expanded, was entitled "Peintres et aquafortistes" and appeared in *Le boulevard* in September 1862.

28. "MM. Manet et Legros unissent à un goût décidé pour la réalité, la réalité moderne,—ce qui est déjà un bon symptôme,—cette imagination vive et ample, sensible, audacieuse, sans laquelle, il faut bien le dire, toutes les meilleures facultés ne sont que des serviteurs sans maîtres, des agents sans gouvernement." Baudelaire, "Peintres et aquafortistes," in *Oeuvres complètes*, 2:738.

29. "[S]ans éducation littéraire, sans éducation artistique." Champfleury, *Chien-Caillou*, 41.

30. "C'est aux environs de la Place Maubert, un quartier où l'on a souvent faim." Ibid., 22.

31. "Quand j'aurai amassé quelque sous, ce qui ne sera pas long, j'achète des planches d'occasion et je me fais un petit bateau. Je mets dedans des pommes de terre, un sac de pain de munition, des carottes, du son pour mon lapin, et puis tout ce qu'il me faut pour graver. . . . Nous allons en Belgique, en Hollande, tout partout où il y a des tableaux de Rembrandt . . . Pendant que nous serons en pleine eau, je graverai. J'aurai aussi quelques économies pour renouveler mes provisions. . . . D'ailleurs, je vendrai mes gravures, je connais des amateurs très-riches en Belgique. Voilà ce que j'ai rêvé toute ma vie." Ibid., 44–45.

32. For more information on this studio-boat, see Madeleine Fidell-Beaufort and Janine Bailly-Herzberg, *Daubigny* (Paris: Éditions Geoffroy-Dechaume, 1975), 48, 261.

33. Although Daubigny painted landscapes directly from *Le Botin*, he did not make etchings on the vessel. To avoid having to travel with etching acid and a cumbersome press, he simply made sketches on board and translated them into etchings afterward.

34. "Ainsi vécurent-ils sur le fleuve, brusquement séparés de la vie sociale, seuls au milieu des silencieuses sérénités de la nature, industrieux et libres, comme les héros populaires de Camp et de Foë, réalisant le rêve longtemps caressé du Chien-Caillou de Champfleury." Frédéric Henriet, *Le paysagiste aux champs: Croquis d'après nature* (Paris: Achille Faure, 1866), 56.

35. "[I]l est temps de plier dans l'armoire l'habit noir des concessions sociales; il est temps d'oublier pour six mois l'hôtel Drouot et les salons officiels, et le marchand et l'amateur. . . . L'heure de départ a sonné!" Ibid., 6.

36. "[I]ls viennent s'escrimer de la pointe et du crayon dans les impasses de jeter sur son oeuvre le frisson de la vie"; "Il est dans une de ces heures fortunées où l'audace réussit, où chaque touche porte coup, où l'oeil et la main sont à l'unisson. Ardent à son but, il a oublié le monde." Ibid., 38, 65.

37. Ibid., 15.

38. "[L]a solidarité de la blouse les rapproche." Ibid., 12. A *blouse* in the context of nineteenth-century French culture was politically charged, associated with the Revolutions of 1830 and 1848 and the proletariat that took part in the battles on the barricades.

39. "Le paysagiste de race n'a rien des élégances du touriste. À le voir, sur la grande route, sac à dos, le bâton à la main, on dirait un colporteur de la bibliothèque bleue ou de l'imagerie d'Epinal." Ibid., 9.

40. Philippe Burty, one of the first admirers to catalogue Meryon's work, was astounded at Meryon's lack of knowledge on artistic matters. See Burty's articles devoted to the artist in the *Gazette des beaux-arts* in 1863.

41. Meryon died in the asylum of Charenton. Chien-Caillou also ended up in an asylum. The story ends with the following phrase: "Le pauvre Chien-Caillou n'est plus aujourd'hui un homme, un artiste, ni un graveur; il est le numéro 13 de la Clinique." ("Poor Chien-Caillou is no longer a man, an artist, an etcher; he is number 13 at the Clinic.") Champfleury, *Chien-Caillou*, 51.

42. An excellent source for contemporary opinion of Meryon's work is Loys Delteil, *Catalogue Raisonné of the Etchings of Charles Meryon*, rev. ed. by Harold J. L. Wright (1924; reprint, San Francisco: Alan Wofsy Fine Arts, 1989). For Baudelaire's statement, see "Peintres et aquafortistes," in *Oeuvres complètes*, 2:741.

43. Delteil, *Etchings of Charles Meryon*, n.p.

44. Ibid., cat. no. 18; translation by William Aspenwall Bradley.

45. Baudelaire proposed to publish a joint project with Meryon but became exasperated by his refusal to listen, exclaiming: "Meryon does not know how to go about things; he knows nothing of life. He does not know how to sell; he does not know how to find a publisher. Yet his work is readily salable." See preface, Delteil, *Etchings of Charles Meryon*, n.p.

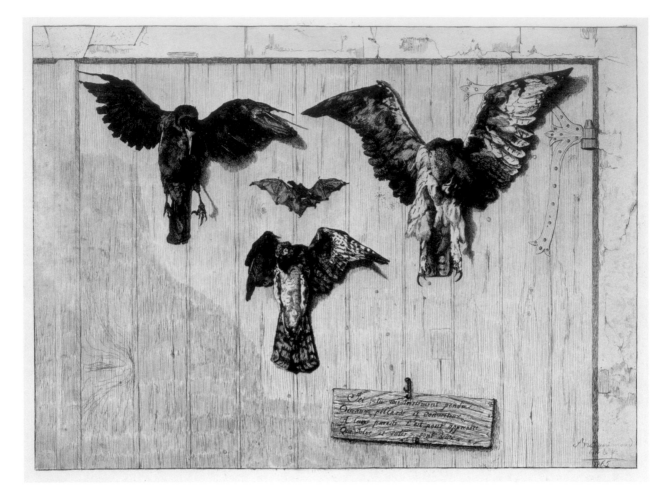

FIGURE 49
Félix Bracquemond
The Upper Part of a Door, 1865
Etching, eighth state
Cat. 7

ALLISON MOREHEAD

Interlude: Bracquemond and Buhot

FÉLIX BRACQUEMOND
The Upper Part of a Door
(Le haut d'un battant de porte)

Félix Bracquemond completed his most celebrated etching, *The Upper Part of a Door*, when he was just nineteen years old. Originally printed in 1852 by Auguste Delâtre, it was enthusiastically received in artistic circles, especially after it was shown at the 1855 Exposition Universelle, but did not sell well. Bracquemond sold the plate, which eventually came into the possession of the publisher Alphonse Cadart.[1] In 1865 Cadart reissued the print, with the new date, in the *Almanach de la Société des Aquafortistes*. The impression in the Smart Museum is from this 1865 edition, corresponding to the plate's eighth state (Figure 49).[2] In 1875 Philippe Burty, the critic and spokesman for the etching revival in France, predicted that it "would one day be as sought after as the best Dutch engravings."[3] The nineteenth-century cataloguer of prints Henri Beraldi noted in 1885 that it had become commonplace to refer to the etcher at the height of his powers as "the Bracquemond of the *Door*," thereby inextricably linking the artist's reputation—literally his name—to the fame of the work.[4] This print furthermore acted as a prototype for the rhetoric of states and impressions that emerged as intrinsic to the logic of the etching revival in France, a logic that would be picked up and modified in Britain and the United States.

In the late 1850s and early 1860s, Bracquemond forged links with Charles Baudelaire, the Goncourt brothers (Edmond and Jules), and Édouard Manet through his printmaking activities. He was an important influence on Manet's etching practice and exhibited with him at the first Salon des Refusés in 1863. Although Bracquemond's work cannot be labeled Impressionist, he participated in the group's frequent meetings at the Café Guerbois and contributed etchings to Impressionist exhibitions.[5] Along with Charles Meryon, he was one of the leading etchers in France, but he also cultivated a distinguished career as a ceramicist, designer, and promoter of *Japonisme*.[6]

According to the reminiscences of Bracquemond's son Pierre, the artist drew the motif of *The Upper Part of a Door* directly from nature, having encountered three dead birds and one bat nailed to a door of a farmhouse in Villers-Cotterêts in northern France.[7] Highly elaborated sketches from the fall of 1852 indicate the assiduity with which Bracquemond attempted to capture the creatures' precise forms and textures, and especially the specific quality of their feathered plumage. By December 1852, he had etched the plate and printed his first proof, which includes the birds and bat but none of the background elements (Figure 50). The four proofs from this first state were given to friends, including Burty, and they were highly prized in the nineteenth century, commanding impressive prices. In 1865 Burty sold the first proof directly to the British Museum, along with a large lot of prints by Meryon, Charles-François Daubigny, Jean-François Millet, and others.[8]

Why did Burty (and perhaps the artist himself) feel that the first proof of *The Upper Part of a Door* belonged in a museum rather than on the open market? In his 1875

FIGURE 50
Félix Bracquemond
The Upper Part of a Door, 1852
Etching, first state
29.7 x 39.1 cm, sheet
1865, 1209.71 © Trustees of the British Museum

essay on the *belle épreuve*, Burty called the first proof the "artist's proof." This nomenclature conferred a special status suggesting that the first proof somehow belonged more to the artist than subsequent impressions.[9] In this first proof, the birds and bat are nearly complete and Bracquemond has evidently printed in order to scrutinize the winged creatures and to begin thinking through possibilities for the background. Rapid and summary pencil marks sketch in the lines of the doorframe, a hinge, some of the planks, and tiny circles indicating the possible placement of wormholes and knots. The print, then, was valued

not only for its extreme rarity, but also for its revelation of the artist's working method. Bracquemond's annotations, identifying it as "1er état 1er épreuve" and providing the date, "20 décembre 1852," further assert the proof as belonging to a specific moment in the artist's life.

Although no impressions from the second state are known today, those from the third state reveal major alterations (Figure 51). Bracquemond has rounded out all four creatures and rendered their plumage much more tactile. In the area around the legs of the bird on the far right, finely etched lines evoke the soft texture of downy

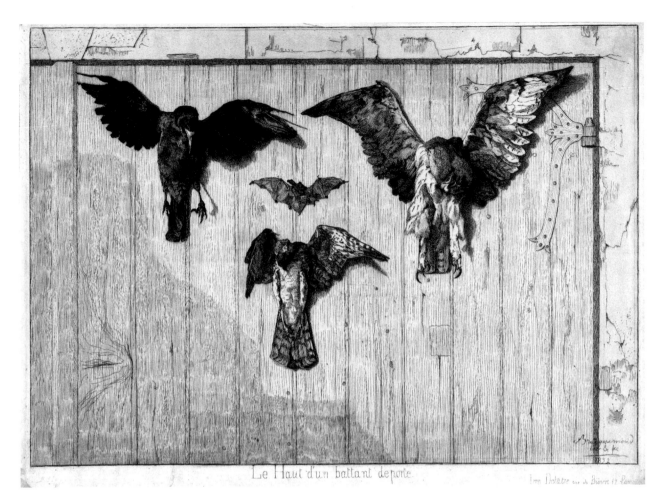

FIGURE 51
Félix Bracquemond
The Upper Part of a Door, 1852
Etching, third state
29.7 x 39.7 cm, sheet
1924, 0112.31 © Trustees of the British Museum

feathers. The artist has deployed an increased variety of lines, cross-hatching, and stippling in order to depict the birds as fully three-dimensional, once-breathing creatures. Nearly all the elements of the background are present in this state. The upper right corner of a wooden door, whose rustic construction is signaled by patched areas, wood grain, and various knots, provides a setting and a framework. Bracquemond has replaced the simple squared-off hinge sketched in the first proof with a curving, decorative element that echoes the shape of the birds' outstretched wings. This more elaborate hinge introduces a dramatic element, contrasting with the roughly constructed door and the cracked and decaying architectural surround.

While the joint of the door in the upper left hand corner suggests a shallow space capable of holding the very three-dimensional birds, other aspects of the background negate the illusion of depth. Following the chamfered plank at left down to the bottom of the print, it eventually appears to lie flat with the other planks, thus threatening the appearance of three-dimensionality. Additionally, Bracquemond's signature at lower right, which cuts across the different spaces of the door and the surround, signals

59

a truth or reality beyond the impressive illusionism of the print itself.

The fourth state is speculative, while the fifth is the "très bel état" mentioned by Beraldi. It is the first known completed version of the print, which now includes the plaque with the moralizing verse, a play on the fact that in French, the verb *voler* means both "to fly" and "to steal":

> Ici, tu vois tristement pendre
> Oiseaux pillards et convoiteux…
> À leur pareils c'est pour apprendre
> Que voler et voler sont deux…
>
> Here you see sadly hung
> Birds both covetous and scavenging…
> To all their kind let their example teach
> That flying and stealing are not the same…

The sixth and seventh "states" are in fact later printings of the fifth state, while the eighth includes the date change in the plate for the Cadart printing.

Even in this early work, Bracquemond's practice was emerging as a model for a new ideal of etching. The detailed annotations and the care with which nineteenth-century critics and cataloguers attentively recorded states and proofs reveal that the pleasure to be had from contemplating Bracquemond's prints went well beyond an appreciation of iconography or the technical skill in an individual impression. Like Burty, who owned a nearly complete suite of states for *The Upper Part of a Door*, the ideal print connoisseur cared equally if not more for creative process, ascribing both aesthetic and economic value to impressions and suites of impressions as potential points of access into the artist's mind.

NOTES

1. Bracquemond described the fate of the plate to Edmond de Goncourt, who recorded the story in a journal entry dated October 2, 1879. For detailed information on Cadart and the Société des Aquafortistes, see Janine Bailly-Herzberg, *L'eau-forte de peintre au dix-neuvième siècle: La Société des Aquafortistes, 1862–1867* (Paris: Léonce Laget, 1972).

2. Jean-Paul Bouillon, *Félix Bracquemond: Le réalisme absolu; Oeuvre gravé 1849–1859; Catalogue raisonné* (Geneva: Skira, 1987), 76–81. Bouillon's numerous publications on Bracquemond, and in particular his catalogue raisonné of the early works, have provided much of the information for this entry. On Burty, see Gabriel P. Weisberg, *The Independent Critic: Philippe Burty and the Visual Arts of Mid-Nineteenth-Century France* (New York: Peter Lang, 1993).

3. Philippe Burty, "Bracquemond's Etchings," *Academy* (November 6, 1875): 487–88; cited in French translation in Bouillon, 80.

4. "Parmi les artistes il est passé en habitude, pour désigner Bracquemond première manière, celui des eaux-fortes originales, de dire: 'le Bracquemond du *Battant de porte*.'" Henri Beraldi, *Les graveurs du XIXe siècle: Guide de l'amateur d'estampes modernes* (Paris: Conquet, 1885), 3:48.

5. For the correspondence between Bracquemond and Manet, see Jean-Paul Bouillon, "Les lettres de Manet à Bracquemond," *Gazette des beaux-arts* 101 (April 1983): 145–58. Bracquemond's work was included in the Impressionist exhibitions up until 1880.

6. For more on Bracquemond's activities outside the realm of etching, see Jean-Paul Bouillon, *Félix Bracquemond, 1833–1914: Graveur et céramiste*, exh. cat. (Paris: Somogy; Vevey: Cabinet cantonal des estampes, 2003); "Remarques sur le Japonisme de Bracquemond," in *Japonisme in Art: An International Symposium* (Tokyo: Committee for the Year 2001, 1980); and *Félix Bracquemond et les arts décoratifs: Du Japonisme à l'Art nouveau*, exh. cat. (Paris: Réunion des musées nationaux, 2005). See also several articles by Gabriel P. Weisberg: "Félix Bracquemond and Japonisme," *Art Quarterly* 32 (Spring 1969): 56–68; "Félix Bracquemond and Japanese Influence in Ceramic Decoration," *Art Bulletin* 51 (September 1969): 277–80; and "Félix Bracquemond and the Molding of French Popular Taste," *Art News* 75 (September 1976): 64–66.

7. Bouillon, *Catalogue raisonné*, 77.

8. Ibid., 80. Although Bouillon notes that the first proof entered the British Museum's collection in 1865, he does not mention that it was purchased from Burty. I thank the staff of the museum's prints and drawings department for allowing me to consult the acquisitions register. The British Museum acquired a second impression in 1866, this time from the 1865 Cadart printing, and impressions from other states in the 1920s.

9. "La belle épreuve," preface to *L'eau-forte en 1875* (Paris: Cadart, 1875). See also Michel Melot, *The Impressionist Print*, tr. Caroline Beamish (New Haven: Yale University Press, 1996).

FÉLIX BUHOT
A Landing in England
(Un débarquement en Angleterre)

By the time Félix Buhot made *A Landing in England* in 1879, printmaking as a mode of creative artistic production was well established in France, and a dedicated group of amateurs increasingly cultivated rarity and the desire for one-of-a-kind prints.[1] The critic Philippe Burty's essay on the *belle épreuve*, published in Alphonse Cadart's *L'eau-forte en 1875*, detailed the myriad ways in which the artist might vary the print not only across states, but across impressions.[2] From variations in inking to the use of different and often unusual papers, to additions in gouache or other media after the print had been pulled, Burty articulated an array of possibilities for signaling the originality of an individual impression. Buhot's work exemplifies the ways in which stakeholders in the nineteenth-century print revival ascribed aesthetic and economic value to impressions that were understood to be at once unique and revelatory of the mysterious processes of artistic creation.

Burty, who met Buhot in 1874 while the latter was working as a painter of decorative arts, had much to do with his rise to prominence as an etcher in the second half of the 1870s.[3] Burty fostered Buhot's etching activities and encouraged his interest in *Japonisme*—in part by commissioning the artist to do a series of prints based on Burty's collection of Japanese objects.[4] Rare impressions from this series, printed on fine Japanese paper that was painted yellow and flecked with gold, attest to the two men's shared interests in the sumptuous original print and in the arts of Japan.[5] Burty was also instrumental in introducing Buhot's work to audiences abroad; by the late nineteenth century, many Americans had become avid collectors of his work.[6]

A Landing in England, which Henri Beraldi called "one of the most curious pieces of the artist's *oeuvre*," is typical of Buhot's elaborate process and of his desire to push the concept of the *belle épreuve* to its limits.[7] The artist insisted on being present at the printing stage and stamped a monogram, usually in red, to identify an impression as having been made under his discerning eye. For Beraldi, this mark, which is visible on the Smart

Museum impression, enabled the amateur to make a distinction between "true *artist's proofs* (what we will call the *artist's* artist's proofs)" and the "*commercial* artist's proofs."[8] In other words, the market for artist's proofs was so well established by the 1880s that the informed collector must, he implied, be somewhat wary. Beraldi noted Buhot's almost obsessive search for old papers, his concern for subtle variations in grain and thickness, and his experimentation with unwieldy techniques such as soaking printing paper in turpentine, which apparently produced highly unusual coloration.

A Landing in England relates to Buhot's own disembarkation at Ramsgate, north of Dover, on his second trip to England in September 1879.[9] The artist's concern for atmospheric weather effects is on full display in the final states of the print, in which Buhot deployed an entire range of etching and engraving techniques in order to capture the dramatic scene. Shown to great success at the Salon of 1880, the print was described by a critic as being the result of something like black magic: "All of the known and unknown resources of engraving have been used: aquatint, drypoint, heavy biting in pure acid—in sum a devil's brew in which the copper is opened wide and the varnish dissolves."[10]

The print depicts passengers disembarking onto a pier as a stormy evening sky darkens around them. Shown from the back, they are rapidly propelled forward by the blustery conditions, a movement heightened by the dramatic perspective of the walkway as it recedes into the background and by the heavily etched lines of driving rain that converge with the lines of the pier at a single vanishing point. In the distance, a flag indicates the strength of the wind, while ships' masts appear dwarfed by the forces of nature.

Gustave Bourcard, Buhot's close friend and cataloguer, described five distinct states of the print, although he admitted that a number of trial proofs effectively constituted intermediate states.[11] The first state is very summary, using only etched lines to sketch in the primary details of the composition. One impression of this state includes white gouache, an addition that both contributes to its status as a *belle épreuve* and suggests the moody chiaroscuro of the ominous sky that Buhot achieved in subsequent

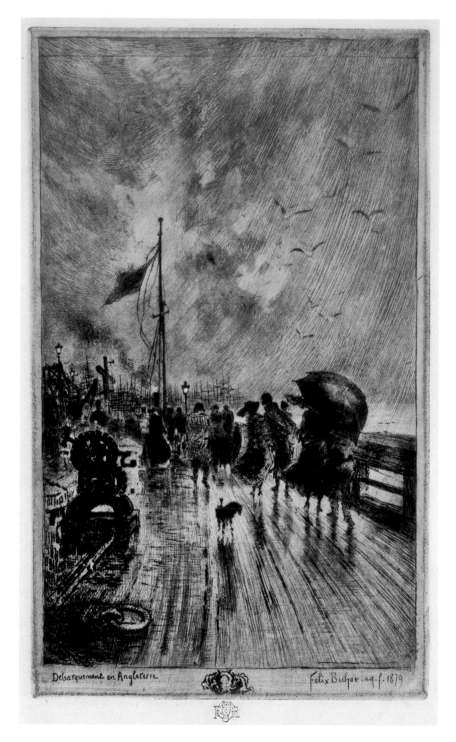

FIGURE 52
Félix Buhot
A Landing in England, 1879
Etching, drypoint, aquatint, and
roulette; fifth state
Cat. 9

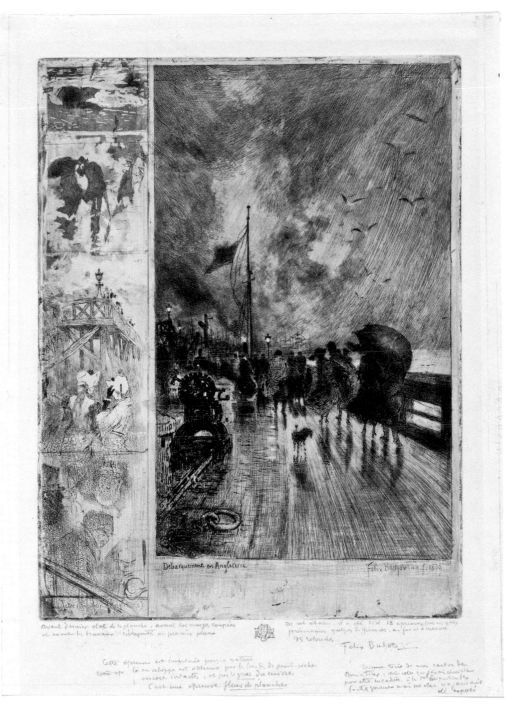

FIGURE 53

Félix Buhot

A Landing in England, 1879

Etching, drypoint, aquatint, and roulette; fourth state

31.9 x 23.8 cm, plate

Partial and Promised Gift from the Helena Gunnarsson

Buhot Collection, 2005.152.4

Image courtesy of the Board of Trustees,

National Gallery of Art, Washington

states with a range of aquatint techniques.[12] In the later states, detailed cross-hatching rounds out the forms of the passengers, liberal use of roulette combines with straight etching to emphasize the perspective lines of the pier, and drypoint in the left foreground describes the thick dark contours of a rather foreboding winch.

Already in the first state Buhot included etched sketches outside the main image, which he continued to develop in the second, third, and fourth states, before cutting the plate and removing the margins in the fifth (Figure 52).[13] Most of the sketches, which appear in the left margin and continue in later states in the bottom margin, are thematically related to the central image. They include a woman holding on to her hat and people seated under umbrellas. Buhot referred to these areas as either "anecdotal" or "symphonic" margins, the latter perhaps in homage to work he had done earlier in his career decorating lithographed sheet music. The practice may also relate to his interest in medieval marginalia or to his knowledge of vignettes in French book illustration; it has been linked to Japanese prints as well.[14]

In the earlier part of the nineteenth century, it was not uncommon for artists to include such sketches and trials— usually called "remarques"—outside the main image in earlier states, indicating various techniques and effects with which they were experimenting.[15] Buhot's sustained practice, however, attracted numerous admirers, and the importance he himself ascribed to these margins made their inclusion highly desirable among amateurs.[16]

In a letter to Bourcard, Buhot identified an impression from the fourth state of *A Landing in England* (with the margins) as one of his most accomplished works, his "most painterly Etching" and nearly priceless:

> that is the impression that I had chosen as being the most beautiful, the most velvety, the richest in tone.... If this amateur is not a true lover of original Etching and of the Belle Épreuve, you must never pass this one on to him, no matter what the price. Because, rightly or wrongly, I consider this State of the plate as the most

characteristic piece, the best that I ever made; it is in any case the most robust, the most painterly Etching. I do not have to tell you that, in spite of the very honorable and even elevated price, I would not part with it if it had not been asked of me by you.[17]

On one impression from this state, Buhot made a number of pencil inscriptions detailing the techniques he used, of which he was evidently proud. These notations appear to justify his identification of this particular impression as the "fleur de planche" (literally "flower of the plate," roughly translatable as "cream of the crop") (Figure 53). They further specify that it is the second-to-last state of the print, before the removal of the margins, and although the stamped monogram is present, Buhot reiterates that it has been pulled in an edition of eighteen "sous mes yeux" ("before my own eyes"). Not only has the artist printed what he considers to be the best impression, he has provided detailed information about how this was done, giving privileged access to his technical processes and, with the inscription itself, adding to the rarity so cherished by amateurs of the *belle épreuve*.

The fact that the margins were removed in the fifth and final state provokes certain questions. While cutting away the trial sketches remained, in Buhot's practice, a way of signaling the end of the printmaking process, for the nineteenth-century amateur and for Buhot himself, the second-to-last state in this case was the work to collect. Was the production of the fifth state, then, even necessary, or just an economic imperative, designed to guarantee the rarity and originality of the earlier states—much like the increasingly common practice of destroying plates? A less discerning or less moneyed collector could still, therefore, own a "Buhot," even if a less coveted one. But if the margins in earlier states were valued for the access they provided to the artist's thought processes as well as connoted rarity, then their removal in a final state was an inevitable and necessary act. Technical experimentation without end, ongoing process, threatened the integrity of the nineteenth-century work of art itself.[18]

NOTES

1. See Michel Melot, *The Impressionist Print*, tr. Caroline Beamish (New Haven: Yale University Press, 1996), 134–38, 160–63.

2. Philippe Burty, "La belle épreuve," preface to *L'eau-forte en 1875* (Paris: Cadart, 1875).

3. Modern sources on Buhot include Jay McKean Fisher, Colles Baxter, and Jean-Luc Dufresne, *Félix Buhot: Peintre graveur*, exh. cat. (Baltimore: Baltimore Museum of Art, 1983); and Jean-Luc Dufresne, Valerie Sueur, and Alison McQueen, *Félix Buhot, peintre graveur: Entre romantisme et impressionnisme, 1847–1898*, exh. cat. (Cherbourg: Isoète, 1998).

4. See Phillip Dennis Cate, "Félix Buhot and Japonisme," *Print Collector's Newsletter* 6, no. 3 (July–August 1975): 64–68.

5. The New York Public Library and the British Museum possess these rare impressions, some of which include red or pink stencils, sometimes cut off seemingly randomly, that make it appear as if the paper was previously used for another purpose. The artist's widow donated one set to the British Museum in 1904 along with a large lot of her husband's prints.

6. See Philippe Burty, *Catalogue of an Exhibition of the Etched Work of Félix Buhot* (New York: F. Keppel, 1888); "Félix Buhot, peintre et aquafortiste," *Journal des arts* (January 31, 1888): 3; "Félix Buhot, Painter and Etcher," *Harpers New Monthly Magazine* (February 1888): 329–35; and "L'art français en Amérique, Félix Buhot peintre et aquafortiste," *Journal des arts* (February 3, 1888): 2–3.

7. Henri Beraldi, *Les graveurs du XIXe siècle: Guide de l'amateur d'estampes modernes* (Paris: Conquet, 1885), 3:32.

8. "[V]raies *épreuves d'artiste* (ce que nous appellerons les épreuves d'artiste *d'artiste*, afin de les distinguer des épreuves d'artiste *commerciales*)." Ibid., 27, 28. Burty repeated and elaborated upon these techniques in *Catalogue of an Exhibition of the Etched Work of Félix Buhot* and "Félix Buhot, peintre et aquafortiste."

9. For a recent discussion of this print, see *The Prints of Félix Buhot: Impressions of City and Sea*, exh. cat. (Washington, DC: National Gallery of Art, 2005).

10. An unnamed critic for *L'art et les artistes*, cited in Fisher et al., *Félix Buhot: Peintre graveur*, 26.

11. Gustave Bourcard, *Félix Buhot: Catalogue descriptif de son oeuvre gravé* (Paris: Floury, 1899), cat. nos. 130, 131. Bourcard's catalogue was republished with corrections in 1979, but he was apparently correct regarding the number of states for *A Landing in England*.

12. Private collection; reproduced in Melot, *Impressionist Print*, 134.

13. Buhot in fact used two practices for his symphonic margins. Sometimes they would start as an integral part of the plate and be removed in the final state. Other times the margins would be printed from separate plates from the outset.

14. On sources for Buhot's use of margins, see Colles Baxter, "Some Notes on Margins: Format, Sources, Meanings," in Fisher et al., *Félix Buhot: Peintre graveur*, 53–61.

15. Ibid.

16. Beraldi emphasized that the amateur "must" have impressions of Buhot's prints with the margins.

17. Félix Buhot to Gustave Bourcard, April 16, 1891, cited at National Gallery of Art, "The Prints of Félix Buhot: Impressions of City and Sea," http://www.nga.gov/exhibitions/2005/buhot/landing_2.shtm (accessed April 16, 2008)

18. Interestingly, Buhot did in fact prolong the technical experimentation of *A Landing in England* with a second print, *A Jetty in England (Une jetée en Angleterre)*, which reverses the scene, makes slight alterations, and includes "symphonic margins" that, although placed similarly, contain entirely different sketches. See Bourcard, *Félix Buhot: Catalogue descriptif*, cat. no. 132.

PEYTON SKIPWITH

Toward a Gothic Vision

ANY COMPLEX IMPULSES spurred the etching revival that swept Europe and America in the sixty years between the Franco-Prussian War and the Wall Street crash, but two are predominant. One was the enduring devotion of a number of artists to what Martin Hardie described as the "teasing, temper-trying, yet fascinating art" of etching; the other was money.[1] The print market during the final decades of the nineteenth century was dominated by reproductive engravings after famous paintings, which were being published in vast quantities by such dealers as Gambart, Goupil Fils, Thomas Agnew & Sons, Arthur Tooth, and The Fine Art Society. This market peaked in financial terms in 1876, when The Fine Art Society paid an incredible £13,500 ($67,500) for the copyright of Lady Butler's famous Crimean War painting, *The Roll Call.* The painting itself was in the Royal Collection; this enormous outlay purchased the exclusive right to make reproductions, the engraved plate—only partially completed and paid for—and a subscription list of potential purchasers, heavy with the names of princes, dukes, and other members of the aristocracy. During the next five years, The Fine Art Society mounted a major exhibition of "Etchings by the Great Masters" from the collection of Seymour Haden, commissioned James McNeill Whistler to go to Venice, and held Samuel Palmer's Memorial Exhibition, which included an important group of his etchings. Palmer's influence on the younger generation was to be a vital element in what I have termed the "gothic" strain in the etching revival.

Seymour Haden, a surgeon by profession and Whistler's brother-in-law, founded the Royal Society of Painter-Etchers in 1880 as a rival to the Etching Club, of which he had formerly been a member.[2] He developed a style that was quite different from the intricate and precise manner practiced by members of the older club, such as Samuel Palmer. As Jerrold Northrop Moore has noted, Haden used a new kind of printing to achieve lighter etchings, favoring a practice called *retroussage*, "where the printer wiped the inked plate with a soft cloth in order to draw excess ink up over the furrows for impressionistic effects." For Palmer, "the new art of retroussage added by the printer upon a comparatively slight fabric" threatened "etching in the old sense."[3]

Haden, much to Whistler's chagrin, was at the time a widely respected authority on the art of etching, a position he recognized in his preface to The Fine Art Society's exhibition catalogue of etchings from his collection:

An impulse has of late years been given to the subject of Etching [*sic*] in this country, for which I cannot but hold myself in some measure responsible, which has done both good and harm: good, inasmuch as it has taught us to be dissatisfied with the colorless platitudes of modern steel engraving; harm, as it has led many to misapprehend, and in practice to abuse, the true aim and end of Etching as a painter's art.[4]

Among Haden's stated aims in mounting the exhibition was to clarify whether etching was "an art worthy of revival" and, if so, "to revive it." The exhibition featured substantial groups by Albrecht Dürer, Wenceslaus Hollar,

FIGURE 54
Charles Meryon
The Vampire, 1853
Etching
Cat. 31

and Rembrandt, as well as over eighty works by Haden himself, including *The Breaking Up of the Agamemnon* (Helsinger, Figure 5).

It is surprising in a way that Haden called the society he founded "Painter-Etchers," as he reputedly had little interest in painting as such. In the first issue of the *Print Collector's Quarterly*, in an article on the etchings of D. Y. Cameron, the editor Frederick Keppel asserted, "Almost every great etcher—such as Rembrandt, Van Dyck, Claude Lorrain, Millet and Whistler—has been a great painter also. The exceptions to this rule are Meryon and Seymour Haden; but then Haden cared little for pictures in colors and Meryon was color-blind."[5] As Haden owned important paintings by Whistler and Legros, however, Keppel's assertion would seem to be at the very least an overstatement.

By an oversight, allegedly "due to haste," Charles Meryon was excluded from the first printing of The Fine Art Society's catalogue—an omission amply repaid in the reprint, where Haden devoted two-and-a-half pages to the man he described as "undoubtedly one of the greatest artists on copper that the world has produced."[6] One of the two works by Meryon included in the exhibition was his somber masterpiece, *The Morgue*, with its shades of Edgar Allan Poe.[7] Haden noted that Meryon's work was not "impulsive and spontaneous, like Etcher's [*sic*] work in general; but reflective and constructive, slow and laborious, and made up less of Etching proper than of touchings and workings on the copper, which do not admit of exact description."[8]

When one looks at *The Vampire* (Figure 54), with its finely wrought surface, it is hard to appreciate precisely

what Haden meant by "Etching proper." I suspect that with his overriding admiration for the etchings of Rembrandt, Haden was inclined, as many others were, to regard economy and expressiveness of line as the chief end of good etching (see Tedeschi essay in this volume, p. 32). Line drawing and blank paper—"the audacious silences of art," as Hardie described them—rather than tone and color, were the fashion of the period.[9] Haden himself, writing to the critic Philippe Burty in 1864, said that "to spend too much time on a picture is to weaken its concentration, to bury its inspiration."[10] It would be interesting to have heard his comments on the etchings of his old confrère from the Etching Club, Samuel Palmer, which were shown in the Memorial Exhibition at The Fine Art Society two years later, though there is no doubt that he admired them despite their differences.[11] Palmer, like Meryon, liked to build up his images with an intricacy of cross-hatching, creating dark surfaces through which gleams and glimmers of light shine. Palmer's images represent a rural idyll and have an elegiac quality reminiscent of Thomas Gray's *Elegy on a Country Churchyard*:

> The curfew tolls the knell of passing day,
> The lowing herd wind slowly o'er the lea,
> The plowman homeward plods his weary way,
> And leaves the world to darkness and to me.

But as with Gray, there is another side, a reminder of darker things. Palmer's *Opening the Fold* (Helsinger, Figure 14) was published in 1880, the same year as Thomas Hardy's *The Trumpet Major*; the public who viewed Palmer's Memorial Exhibition the following year would have been familiar not only with this, but also with *Under the Greenwood Tree*, *Far from the Madding Crowd*, and *The Return of the Native*, and thus aware that behind such seemingly bucolic scenes there often lurked "something nasty in the woodshed."[12] But if he was conscious of any such undercurrents, Palmer gave no hint of it. Meryon, on the other hand, often embellished his scenes with winged figures, devils, and outcasts, as well as the rooks and ravens that add a sinister note to prints such as *The Pont-au-Change*, *The Gallery of Notre-Dame*, and *The Vampire*.

Despite Haden's scholarly interest in the rich diversity of etching throughout its history as an art form, the dichotomy between his own "impressionistic" style and that of Meryon and Palmer is clear. John Ruskin in *The Nature of Gothic* defined the key elements of Gothic as Savageness, Love of Change, Love of Nature, Disturbed Imagination, Obstinacy, and Generosity.[13] Allowing for the jeweled elaboration of Ruskin's prose, and the fact that he was referring specifically to architecture, a combination of these characteristics can be detected in the etchings of Meryon, Palmer, and their successors.

This gothic element in the vocabulary of late-nineteenth-century British etchers, redolent of Ruskin, Victor Hugo, Hardy, and Poe, had been further enhanced by Alphonse Legros's arrival in England in 1863. Legros was a friend of Whistler's from student days in Paris, and in 1876 he succeeded Edward Poynter as Slade Professor at University College, London. Apart from being a fine painter and teacher, Legros was a prolific etcher. In 1860 he etched illustrations for Baudelaire's translation of Poe's *Tales of Mystery and Imagination*, though they remained unpublished.[14] Legros came from Dijon and was steeped in the peasant life of his native Burgundy; he loved the simple ways and the sense of continuity from generation to generation. As Paul Burty Haviland said, his sympathy was so great that it imbued the most material objects and gave "a soul to sunny meadows, trees lost in the fog, valleys swept by storm, and the smoke rising from a burning hamlet."[15] But once again, as indicated by images of burning hamlets, there was another side: the transformation of reaper to Grim Reaper was as natural a part of Legros's artistic repertoire as it was of the mythology and folklore of Burgundy. Coupled with his peasant background was a sophisticated acquaintance with the cultural history of Europe, for, as Laurence Binyon said, "Behind Legros is Ingres, and behind Ingres is Raphael."[16]

Legros passed on to his most adept pupil, William Strang, his facility with the etching needle as well as his ability to depict character, tell stories, and evoke atmosphere through the drawn line. Today we know many great figures of literature—Hardy, Stevenson, Kipling, Galsworthy—through Strang's etched portraits. The architect and designer C. R. Ashbee wrote of Strang, "In each of his portraits there is some touch of his sitters' ugliness revealed in the beauty of the draughtsmanship. . . . [T]hose of us who . . . have sat for our portraits and prize the

FIGURE 55
Alphonse Legros
A Tramp Advancing along a Lane, undated
Etching
Cat. 21

results . . . are also grimly conscious of an unpleasant some-thing in ourselves that we don't like to mention but that our love of truthfulness would not have us conceal."[17] Legros and Strang shared a puritan background, endow-ing simple peasants with pious attributes, as in *A Tramp Advancing along a Lane* (Figure 55) and *The Mother* (Figure 56); equally, and without irony, they both delighted in depicting the devotions of their worldly fellow citizens. The macabre side of Strang comes through at its strongest in the ballads he wrote and illustrated, such as *Death and the Ploughman's Wife*. Like his master, he was always capable of evoking the spirit of Hardy's Egdon Heath, even though the terrain might be different:

> The instincts of merry England lingered on here with exceptional vitality, and the symbolic customs which tradition has attached to each season of the year were yet a reality on Egdon. Indeed, the impulses of all such outlandish hamlets are pagan still: in these spots homage to nature, self-adoration, frantic gaieties,

fragments of Teutonic rites to divinities whose names are forgotten, seem in some way or other to have survived mediaeval doctrine.[18]

This sense of contrast between pagan revelry and solem-nity is evoked by George Clausen in his rare prints such as *A Journey by Night* (Figure 57), a Hardyesque scene that also reflects his admiration for the great painter-etcher Jean-François Millet; Clausen's *Carol Singers* (1890) could easily be a depiction of the mummers in *The Return of the Native*.

Another trait Legros and Strang shared was an ability to imbue with mock-reverence scenes in which Mammon rather than God is worshipped, as in Strang's *Portrait Group of Shipbuilders*, depicting a board meeting of the directors of Wm. Denny & Bros. of Dumbarton, and his 1889 etchings *The Salvation Army* and *A Sale of Prints at Sotheby's* (Figure 58). A penciled note accompanying the British Museum's impression of *A Sale of Prints at Sotheby's* identifies the seated figure to the left, wearing a

FIGURE 56
William Strang
The Mother, 1884
Etching
Cat. 38

FIGURE 57

George Clausen

A Journey by Night, c. 1904

Etching

12 x 15.6 cm, sheet

1928, 1302.1 © Trustees of the British Museum

FIGURE 58
William Strang
A Sale of Prints at Sotheby's, 1889
Etching
30.2 x 38.9 cm, sheet
1953, 0509.115 © Trustees of the British Museum

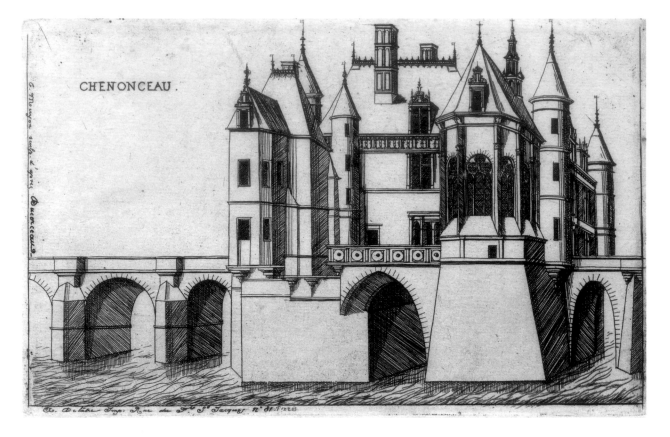

FIGURE 59
Charles Meryon after Jacques Androuet du Cerceau
Château of Chenonceau, 1856
Etching
11.7 x 18.7 cm, sheet
1908, 0616.67 © Trustees of the British Museum

tall hat, as Mr. Ellis of the booksellers Ellis & Elvey, and the standing figures as Legros and the notable collector and patron the Rev. Stopford Brooke. Sotheby's was primarily a bookselling concern, so this image of a sale devoted to prints suggests the burgeoning print market of the late nineteenth century.

It becomes easier to track both the market and changes in taste from 1911, when the first issue of the *Print Collector's Quarterly* was published by Frederick Keppel in New York. This issue carried an obituary of Seymour Haden in which Keppel noted that "some of his rarer etchings sell to-day at prices as high as are paid for first-class etchings by Rembrandt."[19] Keppel's interest in the market and prices is clear from his comments on Meryon in the same issue: "During his lifetime Meryon's price for

any one of his finest proofs was thirty sous—or thirty cents, but as Hamerton says, 'no man regarded it.' Since the year 1868 some of these same proofs have been sold for as much as four thousand dollars each."[20] *The Vampire* was reproduced in the context of this article. Meryon, who had died poverty-stricken in an asylum at the age of forty-seven, was the object of successive articles in the *Quarterly*, reflecting this newfound posthumous veneration for his work. Not all his etchings were as highly wrought as *The Pont-au-Change* and *The Vampire*; in plates such as *Château of Chenonceau* (Figure 59) he displays an ability to use a clean, incisive, gothic line in a manner that prefigures the work of etchers of the early part of the twentieth century: Muirhead Bone, D. Y. Cameron (see Figure 60), and (slightly later) John Taylor Arms. Meryon's

FIGURE 60
D. Y. Cameron
Thermae of Caracalla, 1923
Etching
Cat. 10

influence is most discernible in their architectural and urban scenes.

During the 1910s and 1920s, a clear division of technique, aims, and opinions became apparent between the elegant sketchers—like James McBey, Ernest Lumsden, and Cameron, for whom the line (particularly in their landscapes) was as gentle as a butterfly's breath—and those of a more robust or gothic temperament. This division reflects the continuance of two different traditions following Haden and Palmer. Campbell Dodgson ridiculed the extreme practitioners of the butterfly's-breath school, noting that "the art of omission has been practiced almost to vanishing point." He maintained not only that sustained inspiration was a greater gift than momentary inspiration, but also that "the sustained attention needed to appreciate

a finely wrought masterpiece is better than the hasty glance with which a trained eye seizes in a moment all that the 'spontaneous' sketch contains."[21] Dodgson developed this argument in an article on the work of Frederick Landseer Maur Griggs, the spiritual heir of Palmer, in whose intricacy of cross-hatching there was "always light enough for the eye to penetrate into the gloomiest depths." He noted that prints such as *The Ford* of 1915 (Figure 61), which represented buildings that did not actually exist, were "beautiful and entirely credible figments of the artist's imagination." And, waxing lyrical, he went on to describe the "garden courts and river fronts of stone houses, these covered bridges and flagged terraces by the waterside, these vistas bordered by trim walls of box, and leading past hollyhocks and sundials to gables and roofs of Cotswold

FIGURE 61
F. L. M. Griggs
The Ford, 1915
Etching
Cat. 15

stone."[22] In many ways he was echoing Ruskin, who, a century earlier, had written of "that strange disquietude of the Gothic spirit," describing the "restlessness of the dreaming mind, that wanders hither and thither among the niches, and flickers feverishly around the pinnacles and frets and fades in labyrinthine knots and shadows along the wall and roof."[23] In the catalogue of prints appended to Dodgson's article, Griggs would not permit work prior to *Sutton* of 1912 to be listed, for he regarded this plate as marking the commencement of his mature style. A recent biographer of Griggs, though fully cognizant of the fact that Palmer was his "first & last love," noted the dichotomy between them: "Where Palmer's late lights had celebrated survival, Griggs's hinted at impending loss."[24] Nowhere is this truer than in his great late etching *Memory of*

Clavering (Figure 62), done in 1934, when, due to severe financial pressures, his life and his dreams were crumbling, and he had only his faith to sustain him.

The avant-garde vocabulary available to artists from about 1910 onward, with the advent of abstraction, became almost unlimited: Cubism, Futurism, Vorticism, Orphism, Dadaism, and, later, Surrealism. Yet it is interesting to note that a number of those who chose to remain within the figurative tradition opted for an uncompromisingly gothic stance, not only in terms of subject matter, but also in terms of line and simplicity of structure. This comes through clearly in the etchings and line engravings of Robert Austin, such as *Man with a Crucifix* of 1924 (Figure 63), and of Gerald Brockhurst. Dodgson regarded both Austin and Brockhurst as worthy of sustained attention, but his

FIGURE 62
F. L. M. Griggs
Memory of Clavering, 1934
Etching
Cat. 16

commendation could equally apply to the etchings of Stanley Anderson, Ethelbert White, and Evelyn Gibbs. A similar quality is also discernible in the drawings and early paintings of Stanley Spencer, Mark Gertler, Winifred Knights, Thomas Monnington, and others. It is not coincidental that several of them were winners or runners-up for scholarships at the British School at Rome and had, like Griggs, studied under Henry Tonks at the Slade School.

Brockhurst was a prodigy. Suffering from severe learning difficulties, but adept at drawing, he had entered Birmingham School of Art at the precocious age of twelve; there he won virtually every award before progressing, in 1907, to the Royal Academy Schools in London. He continued to carry off prizes, medals, and decorations in abundance, culminating in the Gold Medal and Scholarship of

£200, the most coveted award a student could receive. Untutored in printmaking, Brockhurst etched his first plate as an experiment the year after he left the Academy Schools; he quickly made his mark with such studies of female beauty as *The Lace Hat*, *Paquita*, and *Mélisande*. The acme of his achievement was *Adolescence* of 1932, one of the most staggering etchings of the entire twentieth century: the subject is a pubescent girl seated at her dressing table, studying her naked form in the mirror with a look of both awe and apprehension. The fine hatching, velvety tones, and intensity of concentration and mood certainly command, in Dodgson's words, "the sustained attention needed to appreciate a finely wrought masterpiece." In contrast to this vision of young womanhood, Brockhurst's *The Connemara Peasant* (Figure 64), dating from the

77

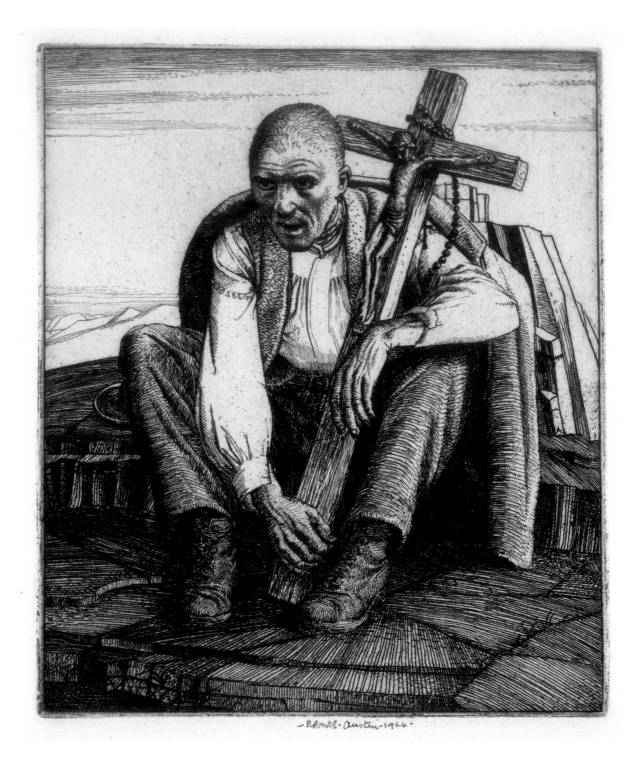

FIGURE 63

R. S. Austin

Man with a Crucifix, 1924

Etching

Cat. 4

Reproduced by kind permission of

Rachel Austin

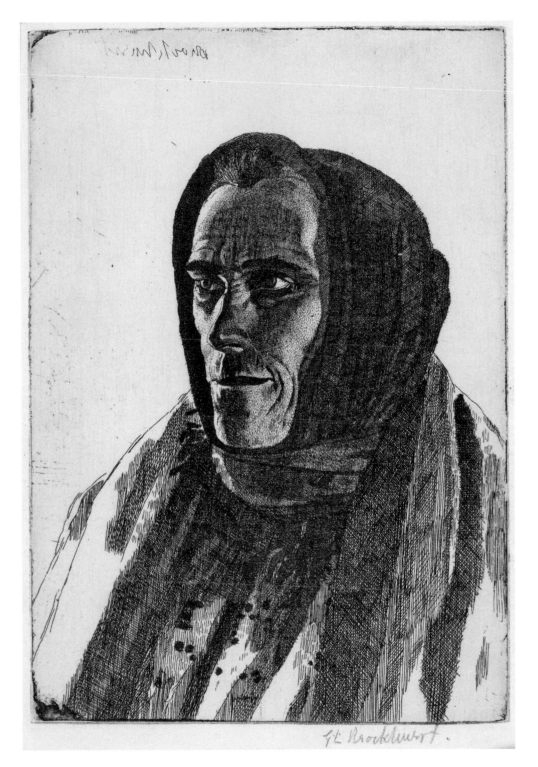

FIGURE 64

Gerald Brockhurst

The Connemara Peasant, 1921

Etching

16.3 x 11.2 cm, sheet

1921, 0610.3 © Trustees of the British Museum

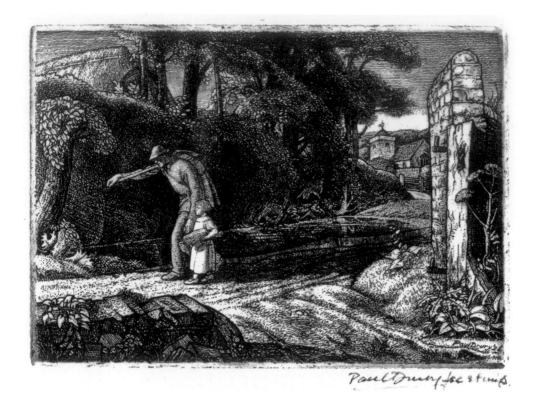

FIGURE 65
Paul Drury
After Work, 1926
Etching
14.2 x 10.2 cm, plate
Photograph: Estate
of Paul Drury

early 1920s, depicts a distinctly masculine-looking Irish fish-wife; but here also, he has created a powerful image of gothic intensity. Hugh Stokes, commenting on Brockhurst's "consummate skill of exact draughtsmanship," noted that "not since Frederick Sandys has any English artist commanded such powers of accurate and precise statement of fact."[25]

Griggs's passionate devotion to the work and meticulous printing of Samuel Palmer inspired a group of younger artists at Goldsmiths' College at New Cross in South London, most particularly Paul Drury, Graham Sutherland, William Larkins, and Bouverie-Hoyton: "the Class of '21," as they dubbed themselves. In the aftermath of World War I, there was a rapid turnover of teachers in the etching class at Goldsmiths', precipitated by the death from injuries of Alfred Bentley; between 1921 and 1924, this group of students was taught successively by Bentley, Frederick Marriott, Malcolm Osborne, and Stanley Anderson. Writing of that period, Sutherland recalled,

We were a close little band between 1922 and 1928 at the School of Art. . . . One might say that in our

different ways we were rebellious and certainly critical of the teaching at that time in general, in the engraving school in particular. The teaching in that department, while probably good in basic technical matters, tended to follow the conventional lines laid down by Sir Frank Short at the Royal College of Art. We ourselves did pastiches of Rembrandt, Dürer and Whistler, and, thank God, we knew of Charles Meryon. Ignorant we may have been at New Cross—but not all that ignorant. We visited museums and knew a few private collections, notably that of Campbell Dodgson and through our friend Paul Drury, the beautiful collection of his father the sculptor Alfred Drury.[26]

The body of work produced by this little coterie, inspired by Palmer and Griggs, was an intense late flowering of the pastoral tradition. As beautiful and unexpected flowers blossom amidst ruins, so the spirit of Palmer flourished again in the wake of the Great War. Drury's *After Work* (Figure 65) is a fine example of this, as are Sutherland's *Pecken Wood*, *Lammas*, and *St. Mary's Hatch*. However, two of Sutherland's most extraordinary etchings, *The Expulsion* and *Cain and Abel* (Figure 66), dating from 1924, owe

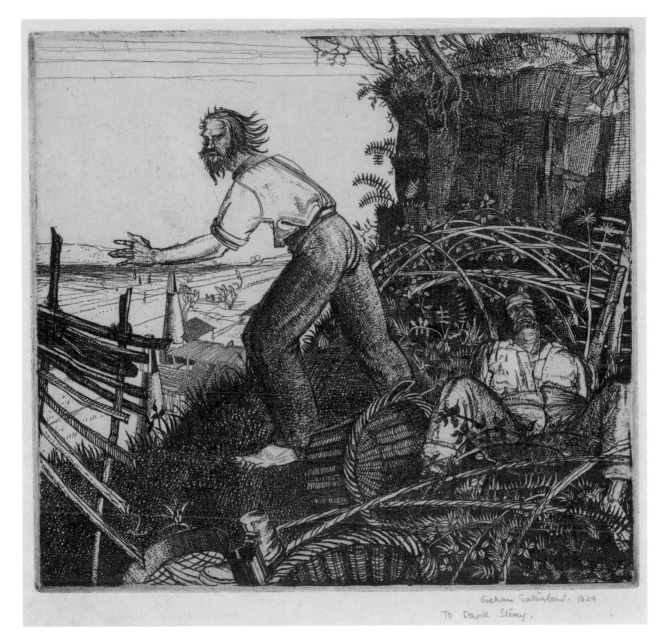

FIGURE 66
Graham Sutherland
Cain and Abel, 1924
Etching
17.7 x 19.1 cm, sheet
1960, 0409.369 © Trustees of the British Museum

BEHOLD, THERE WAS A MAN
NAMED JOSEPH, A COUNSELLOR;

FIGURE 67
Eric Gill
"The Burial of Christ (Luke 23),"
from *The Four Gospels*, 1931
Wood engraving
22.5 x 19.5 cm, image
Photograph: University of Chicago Library,
Special Collections Research Center

nothing to Palmer but look back to an even earlier gothic tradition. *The Expulsion* and *Cain and Abel* were the compulsory subjects that year for the exam for the Prix de Rome, and although Sutherland was always critical of his teacher, they appear to owe a considerable debt to Anderson.

Although the members of the Class of '21 at Goldsmiths' regarded themselves as modern young rebels, Griggs's heart was firmly in the past: Dodgson commented that as a Roman Catholic, Griggs deplored the Reformation, while as an architect, he deplored the Renaissance. He commissioned his fellow Catholic convert, Eric Gill, to design and cut a *DHP* colophon for his Dover House Press, which he stamped in the margins of the prints he pulled himself.[27] Gill—sculptor, wood engraver, writer, and polemicist— was, like Griggs, steeped in the gothic tradition. His *Four Gospels*, printed by Robert Gibbings at his Golden Cockerell Press, is a masterpiece of twentieth-century printing (Figure 67). Gill, Gibbings, Eric Ravilious, Ethelbert White, Gwen Raverat, Clare Leighton, Blair Hughes Stanton, Gertrude Hermes, and others were among the principal figures behind the 1920s English revival of wood engraving, which for a period came to rival etching

in popularity. This revival was driven in part by the near-insatiable demand for well-illustrated books, for which wood engraving was particularly suitable, since the blocks could be set and printed alongside letterpress type. A measure of the popularity of wood engraving was the establishment of the Society of Wood Engravers (1920) and the English Wood Engraving Society (1925). Clare Leighton, an associate member of the former, like many of the printmakers already mentioned, was strongly influenced by the writings of Hardy. In 1929 she illustrated an edition of *The Return of the Native*. A few years later, in *The Farmer's Year* (1933)—an almanac described as a "somber vision of life on the land"—she developed her Hardyesque conception of man's struggle with nature. Gill, who wrote about it for the left-wing publisher Victor Gollancz, said, "No one in our time has succeeded better in presenting the nobility of massiveness and breadth of life of the earth on a scale so grand."[28] Although born in London, Leighton moved to the United States and successfully transferred her "somber vision of life on the land" to the city.[29] *New York Breadline* (Figure 68), engraved during the depths of the Depression, shows a mechanistic and hopeless line of

FIGURE 68
Clare Leighton
New York Breadline, 1932
Wood engraving
Cat. 22

workers crushed both by circumstances and by the dark, chasm-like street, whose massive skyscrapers symbolize an earlier prosperity.

Although in the above I have concentrated on one particular manifestation of the etching revival, there were many other distinguished etchers—Walter Sickert, Frank Brangwyn, C. R. W. Nevinson, William Walcot, and Charles Tunnicliffe among them—who did not choose this means of expression, and who are thus not mentioned here. They too suffered, along with all the others who lived through the crash of 1929 and the ensuing years of the Depression. The etching market had been ruthlessly exploited, to the point where new editions of prints by Brockhurst, Cameron, Griggs, and McBey were over-subscribed before they were even published; the crash totally annihilated it. The disillusionment among investor-collectors and speculators was so great that it was another forty years before the market began to revive. Those artists lucky enough to be "painter-etchers" were forced to rely on the former skill to eke out their living; others turned to teaching or commercial art. As his biographer describes, Griggs was working on his print *The Maypole Inn* "when news came of a catastrophic crash in the American stock market. . . . *The Maypole Inn*

attracted only twenty-eight subscribers, most of them friends."[30] Colnaghi, Griggs's dealer, returned unsold prints, something that would have previously been inconceivable. Despite this, five years later Griggs was still writing optimistically to his friend Russell Alexander, "*Memory of Clavering* is being praised more than any plate I've done. It looks as if it might drive the wolf from the hearth rug!"[31] It was not to be.

One young artist, James McIntosh Patrick, who was just beginning to make a name as an etcher, was fortunate to have a contract to produce four etchings a year for the publisher Harold Dickins. Dickins honored his side of the bargain, but told Patrick not to waste his time producing the plates as there was no market for the prints; Patrick subsequently went on to become the most revered Scottish landscape painter of the mid-twentieth century.[32] For him and for the others, the etching revival was dead. Even when the art market began to revive in the 1950s and 1960s, there was little interest in black and white; the emphasis was almost entirely on explorations in color by the Abstract Expressionists. It was only in the early 1970s, as a new generation began to reassess the past, that a fresh appreciation of the rich heritage of printmaking of the 1880–1930 period began to manifest itself once again.

NOTES

Peyton Skipwith would like to thank Antony Griffiths and the staff of the Print Room at the British Museum for their assistance, and Gordon Cooke and Lord Irvine of Lairg for kindly reading this essay in draft and offering helpful suggestions.

1. Martin Hardie, "The Etched Work of Samuel Palmer," *Print Collector's Quarterly* 3 (April 1913): 212. Hardie was Keeper of the Department of Painting, Engraving, Illustration and Design at the Victoria and Albert Museum, London, 1921–35, and author of *The British School of Etchers* (1921).

2. Some account of the Old Etching Club and the Junior Etching Club is given in Walter Shaw Sparrow, *A Book of British Etching* (London: J. Lane, The Bodley Head, 1926). Members at various times included J. E. Millais, Holman Hunt, Thomas Creswick, and Richard Redgrave, as well as Palmer and Whistler.

3. Jerrold Northrop Moore, *The Green Fuse: Pastoral Vision in English Art, 1820–2000* (Woodbridge, Suffolk: Antique Collector's Club, 2007), 70.

4. Seymour Haden, *About Etching: Notes by Mr. Seymour Haden on a Collection of Etchings and Engravings by the Great Masters lent by Him to The Fine Art Society to Illustrate the Subject of Etching* (London: The Fine Art Society, 1878–79), iii.

5. Frederick Keppel, "D. Y. Cameron," *Print Collector's Quarterly* 1 (January 1911): 74.

6. Haden, *About Etching*, 42. The Fine Art Society's catalogue was reprinted several times during the run of the exhibition, allowing Haden to revise and expand his *Notes*.

7. Poe's story "The Murders in the Rue Morgue" first appeared in *Graham's Magazine* in April 1841.

8. Haden, *About Etching*, 42.

9. Hardie, "Etched Work of Samuel Palmer," 208.

10. Haden, quoted in Kenneth Guichard, *British Etchers, 1850–1940* (London: Robin Garton, 1981), 9.

11. At the time of writing (April 2008), The Fine Art Society had in stock a proof of Palmer's *The Morning of Life* printed and annotated by Haden.

12. A reference to Aunt Ada Doom's—old Mrs. Starkadder's—oft-reiterated refrain in Stella Gibbons's gothic novel *Cold Comfort Farm* (London: Longmans, Green and Co., 1932).

13. For a detailed analysis, see John Ruskin, "The Nature of Gothic," in *The Works of John Ruskin: Library Edition*, ed. E. T. Cook and A. Wedderburn (London: George Allen, 1903–12), 10:184–204.

14. The largest collection of Legros's prints is in the Boston Public Library.

15. Paul Burty Haviland, "Alphonse Legros," *Print Collector's Quarterly* 2 (December 1912): 436–37.

16. Laurence Binyon, "The Etchings and Engravings of William Strang," *Print Collector's Quarterly* 8 (December 1921): 352.

17. C. R. Ashbee, Memoirs (typescript), vol. IV, p. 70 (National Art Library, Victoria and Albert Museum, London); quoted in Philip Athill and Anne L. Goodchild, *William Strang RA, 1859–1921: Painter-Etcher*, exh. cat. (Sheffield: Sheffield City Art Galleries, 1980), 22.

18. Thomas Hardy, *The Return of the Native* (London: Macmillan, 1927), 456–57.

19. Frederick Keppel, "Seymour Haden," *Print Collector's Quarterly* 1 (January 1911): 9.

20. Frederick Keppel, "Charles Meryon," *Print Collector's Quarterly* 1 (January 1911): 63.

21. Campbell Dodgson, "The Etchings of F. L. Griggs," *Print Collector's Quarterly* 11 (February 1924): 95–96. Dodgson was appointed to the staff of the Department of Prints and Drawings at the British Museum in 1893, and was Keeper from 1912 to 1932.

22. Ibid., 102.

23. John Ruskin, "The Nature of Gothic," in *Works*, 10: 214.

24. Moore, *The Green Fuse*, 99.

25. Hugh Stokes, "The Etchings of G. L. Brockhurst," *Print Collector's Quarterly* 11 (December 1924): 420.

26. Graham Sutherland, foreword to *The English Vision*, exh. cat. (London: William Weston Gallery, 1973); quoted in Jolyon Drury, *Revelation to Revolution: The Legacy of Samuel Palmer* (Ashford: J. Drury, 2006), 27.

27. In addition to printing many of his own etchings, Griggs took impressions from some of Palmer's plates as well as those of his young protégés. The British Museum's impression of Sutherland's *The Village* bears Griggs's *DHP* colophon.

28. Eric Gill, quoted in *Oxford Dictionary of National Biography*, (Oxford: Oxford University Press, 2004), vol. 33, s. v. "Leighton, Clare Ellaline Hope."

29. Leighton became an American citizen in 1939.

30. Moore, *The Green Fuse*, 118–19.

31. Quoted in Jerrold Northrop Moore, *F. L. Griggs, 1876–1938: The Architecture of Dreams* (Oxford: Clarendon Press, 1999), 244.

32. In an article in the *Print Collector's Quarterly* 17 (April 1930), when Patrick was only twenty-three, Max Judge wrote, "True genius has no need to violate propriety, and Patrick's modernity is proof against the anarchy that is no less a *cul-de-sac* in art than the 'representation' so dreaded by ultra-moderns" (200). Judge went on to relate Patrick's use of pictorial space to that of Mantegna.

FIGURE 69

Charles Meryon

Turret, Rue de l'École de Médecine, 22, Paris, 1861

Etching

Cat. 30

Postlude: Reflections on Some Impressions

FIGURE 70
Joseph Webb
The Prison, 1930
Etching
Cat. 39

MERYON AND WEBB

Charles Meryon's *Turret, Rue de l'École de Médecine, 22, Paris* (Figure 69) presents an urban scene of bustle and activity on a nineteenth-century street, all overshadowed by the tower of the title. The viewer's gaze moves from the busy intersection to the pinnacle of the tower and from there to the roof across the street, where two small workers seen from a distance emphasize the height of the imposing edifices that wall in the city dwellers. The workers themselves look up toward an ominous sky, which,

in the earlier states of the etching, included a rather Blakean set of figures: allegories of Truth, Justice, and Oppressed Innocence. The tenth state of the etching also bore the inscription "Holy, inviolable Truth, Divine torch of the Soul, when Chaos is on Earth, you descend from the heavens to enlighten men and regulate the decrees of strict Justice." In subsequent states, the etching was stripped of its allegorical and apocalyptic significance, leaving a scene that is still resonant of the Oppressed Innocence from

which Truth and Justice were to provide freedom. Though the rooftop workers may be distant from the street "Chaos," they have not escaped the city's oppression. Dominated by the tower and the portentous sky, they seem to bow under their weight. Even without the divine figures that once occupied the sky, the etching nevertheless retains an eerie sense of pervasive and unnamable urban oppression from which there is no clear liberation, divine or otherwise.

The art of Joseph Webb, an etcher working in the following century in Britain, also exudes a deep spiritualism and romantic vision. We see in Webb's etchings the influence of Blake as it survives through Samuel Palmer and then F. L. M. Griggs, whom Webb met in 1929. Like Griggs (see Figures 61 and 62), Webb favored densely etched pastoral settings and haunted architectural spaces, but he infused his buildings (often ecclesiastical ones) with

a sense of peace and spiritual affirmation. *The Prison* (Figure 70) is unusual in Webb's oeuvre in that it presents a startlingly bleak and threatening structure surrounded by a lifeless landscape. This work is particularly evocative of a modern sense of alienation; it is a "Waste Land," which readers of T. S. Eliot's 1922 poem would have recognized. Comparing the solemn sanctuaries of Webb's other etchings with the prison in this one dramatizes the tension between those forces and institutions surrounding us that leave us feeling alternately sheltered and "caged," as the inscription has it. It is quite interesting to compare Webb's prison and Meryon's turret with regard both to their formal features and to their expression of entrapment. While not explicitly a war-themed etching, *The Prison*, with its low horizon, is highly reminiscent of the devastated and barren landscapes etched by Percy Smith and Kerr Eby after World War I (see Figures 13 and 22).

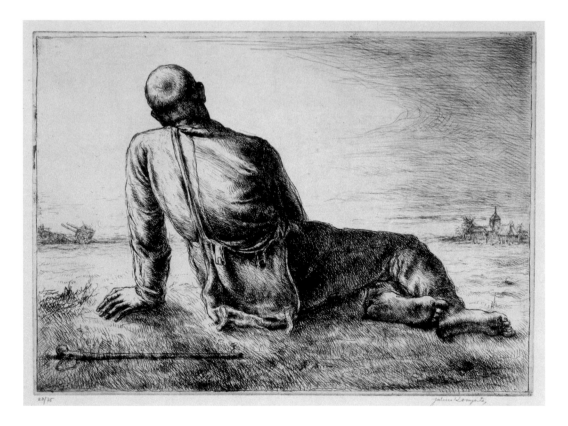

FIGURE 71
Julius Komjati
Morning, 1919
Etching
Cat. 19

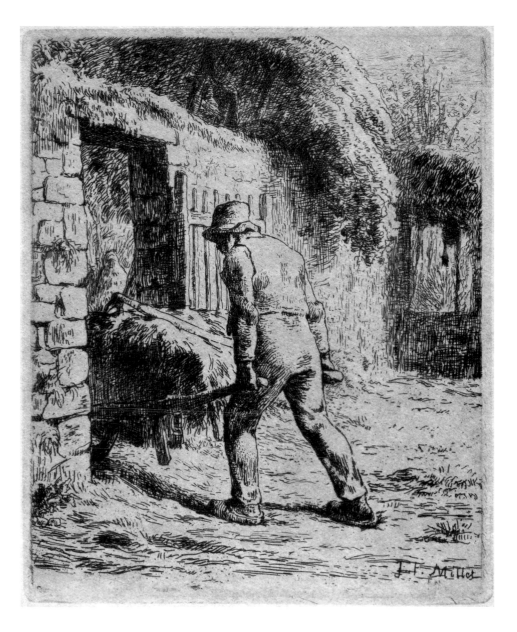

FIGURE 72
Jean-François Millet
*Peasant Returning from the
Manure Heap*, 1855
Etching
Cat. 32

KOMJATI, MILLET, AND AUSTIN

The Hungarian etcher Julius Komjati won a government grant to study the graphic arts in England, where he stayed from 1928 to 1938. Komjati's spiritual and introspective artistic vision was significantly influenced by his experience as a prisoner of war of the Romanians from October 1916 to February 1918; he was one of only two thousand survivors among the original sixteen thousand captives.[1] *Morning* (Figure 71), like many of Komjati's etchings, recalls the landscape of his native Hungary. Yet it is less about natural features and the moment of sunrise than about the

reclining figure who fills the frame. The image is strangely intimate: although we do not see the man's face, there is a certain tenderness in the portrayal of the soles of his bare feet, for example. We look over his shoulder as if to experience with him the moment of peace and solemnity before the day's labor begins.

Similarly, Jean-François Millet's much earlier *Peasant Returning from the Manure Heap* (Figure 72) shows only the back of the subject in a posture that carries the emotional charge of the etching. The laboring peasant returns

FIGURE 73
R. S. Austin
The Mendicants, 1924
Etching
Cat. 5
Reproduced by kind permission of
Rachel Austin

with his wheelbarrow through a stone doorway as the set-ting sun casts a long shadow on his activity. Millet's figure, however, seems a part of the landscape, whereas Komjati's figure resists integration, displacing the sky and sur-rounding countryside. Millet's etching is characteristic of mid-nineteenth-century rural realism of which he was a leading exponent. The son of a peasant farmer, he most frequently took as his subject laboring rustics, whom he rendered in well-known paintings such as *The Gleaners* (1857; Musée d'Orsay, Paris).

The two slightly hunched figures in Robert Austin's *The Mendicants* (Figure 73) of 1924 are, like Millet's peas-ant, approaching a doorway and engaged in a type of labor, here begging for alms. But rather than representing the muscular vigor of a body toiling for its daily bread, Austin portrays dejected panhandlers haggard with penury and petitioning. Absent is the sentimentality or nostalgia that marks the etchings of Komjati and Millet, and there is even less assimilation of the men into their surroundings.

Featuring a blank wall and only the sparest suggestion of a doorway, Austin's etching highlights the outcast and rejected status of beggars.

By comparison with Millet's *Peasant*, we can perhaps catch glimpses of what Kenneth Guichard described as Austin's "cold angularity," "diagnostic attitude," and "chilly meticulous classicism."[2] These qualities notably charac-terize Austin's *The Bell #1* (Figure 74), a work that in some respects recalls Albrecht Dürer's *Melencholia I*. In addi-tion to features such as the bell itself, the two works share certain shapes and structures: one can liken the spokes of the half-wheel to the radiant semicircle in the background of *Melencholia I*, and the roof beams of the interior with Dürer's angled ladder—even though Austin's geometric patterning is not employed in the service of symbolism. In contrast to Dürer's winged personification of Melancholy, Austin's two pigeons, one of which preens itself, demystify the scene and mitigate the "cold" or "chilly" potential of this engraving masquerading as an etching.

90

FIGURE 74
R. S. Austin
The Bell #1, 1926
Engraving
Cat. 3
Reproduced by kind permission of
Rachel Austin

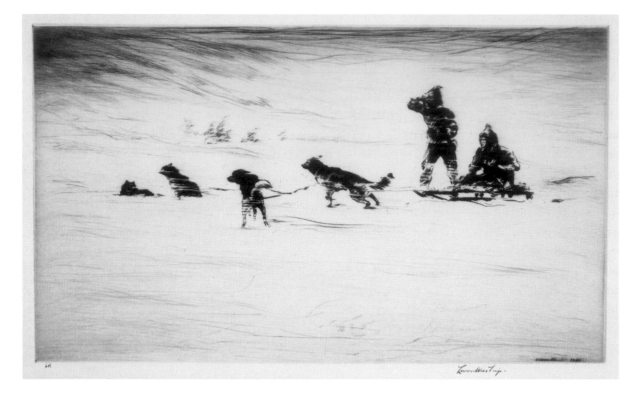

FIGURE 75
Levon West
Blizzard Coming, 1931
Etching and drypoint
Cat. 40

WEST AND MCBEY

An article in *Time* magazine of February 10, 1930, comparing the etching markets of the U.S. and Britain proclaimed that American etchers, print dealers, and print lovers had grown so independent of their British counterparts that "[c]ertain British print dealers gasped with astonishment and dismay last week when they received back from three Manhattan art establishments several unopened packages of prints by noted [British] artists" such as D. Y. Cameron.[3] The article then advises that any "well-rounded" collection of American etchings should include works by John Taylor Arms, Levon West, Martin Lewis, and Kerr Eby, among others. The writer offers brief sketches of these artists, framing their etching accomplishments (and prices of their works) within peculiar biographical notes in a way that intriguingly recalls the earlier rhetoric used to portray etching as the direct expression of the artist's mind (see

Tedeschi essay in this volume, p. 25). The article says of Levon West that he

> likes to wander amid the lonely buttes and lakes of the Northwest, hunting and sketching, when he is not doing Houdini tricks with cards or taking rabbits out of the pockets of his friends. . . . He came to know Charles Augustus Lindbergh, and etched his portrait directly on copper plate from memory, aided by a photograph, the day Lindbergh landed in Paris. Exhibited in Manhattan while Paris was still cheering, that bit of work did much to establish West.

In this figuration, West has a magical (Houdini-like) authority—he becomes a master of sleight-of-hand as his deft wielding of the etching needle invokes the "Spirit" of the plane and its pilot from memory. The speed of

etching not only allowed the result to be swiftly exhibited, but it also made the medium particularly suitable for rendering flight.

Moreover, West is presented as the solitary artist communing with nature, a voice in the wilderness who commands a certain authenticity (like Kerr Eby, who "prefers to wander amid wild marshes [and] fish in the surf").[4] The article would have us picture West braving the elements just like the solitary dogsledders in prints such as his *Blizzard Coming* (Figure 75). When seen as a representation of something (possibly) experienced by the printmaker with a direct connection to nature (instead of as a scene imagined from inside an artist's studio), the work has an immediacy for which the medium was celebrated. *Blizzard Coming*, with its spare use of line, convincingly renders atmosphere, energy, and movement, and thus

captures the severity and bleakness of the harsh winters West witnessed during his time in the Dakotas, Minnesota, and Canada.

West's image of this struggle with the elements can be fruitfully compared to the work of the Scottish etcher James McBey, particularly *Sea and Rain* (Figure 76), one of many depictions he made early in his career of the coastal region of his native northeastern Scotland. In this print we likewise have an impressionistic rendering of atmospheric effects in order to capture mood. McBey later applied this style to locales outside Scotland, such as a Venetian canal in *The Bridge by Night* (Helsinger, Figure 7). West's etchings, like McBey's, demonstrate the capacity of a highly skilled printmaker to create an intensely charged and dramatic image through seemingly scribbled yet highly controlled lines.

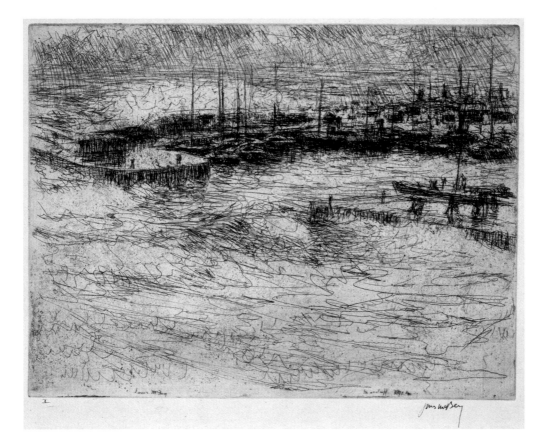

FIGURE 76
James McBey
Sea and Rain, 1914
Etching
Cat. 28

EBY AND WAR ETCHERS

Etching played a prominent role in recording and representing the conflicts of the First and Second World Wars. Muirhead Bone, who is considered the first official war artist of Britain, was called up to serve in the spring of 1916.[5] He twice went to France, and his etchings were regularly reproduced and widely circulated in the official magazine *War Pictorial*. The Canadian government commissioned landscapes of the Western Front from D. Y. Cameron. His paintings were never translated into etchings, however, because they too much resembled his romantic portrayals of the Scottish Highlands; they avoided the front's unpleasantness in favor of picturesqueness. McBey served at Boulogne in 1916, was assigned the following year to be the official artist to the Palestine Expeditionary Front, and continued his service as artist for the War Office into the 1920s. Several of his etchings of the Sinai Desert were very well received, such as *Dawn: Camel Patrol Setting Out*, which set auction records. Robert Austin was a gunner in the Royal Artillery during World War I, after which he returned to the Royal College of Art to study under Frank Short; Austin then served as an official war artist for the RCA during World War II. John Taylor Arms was a naval officer in the First World War, and in the Second he volunteered to make drawings and prints of ships and architectural structures for the Navy. He was also instrumental in forming the organization Artists for Victory, which provided opportunities for civilian artists to contribute to the war effort through their craft.

Percy Smith was an early volunteer in the Great War, but unlike Bone and others, he was a war artist only unofficially. Throughout his service, he made sketches of his observations and even had a few etching plates smuggled out to him in between magazine pages. His allegorical etchings of World War I, collectively known as the *Dance of Death* (see Helsinger, Figure 13), were created back in Britain during a period of leave. Smith wrote that "'Death Awed' was etched almost entirely at one sitting."[6] The intensity and immediacy that imbued the *Dance of Death* were grounds for criticism. In 1922 one reviewer noted that although Smith yearned for calm expression through "beautiful line" and "noble grouping," the etchings in this series were tainted by a "too violent and ungoverned" impulse.[7] Perhaps in response to this review, or others like it, British etcher E. S. Lumsden wrote in 1925,

> The present-day public is incapable of judging [Smith's] "Dance of Death"... purely from the aesthetic point of view. It does not wish to be reminded of the all too recent bitterness of loss, but in time to come these plates will, I feel sure, be looked upon as the most searching commentary on the horrors of the Great War produced in this country: perhaps in any.[8]

In the 1920s, the desire of the public to bury the memory of the war affected the critical and financial success of representations of it, both in Britain and in America.[9] However, Lumsden was indeed prescient in his comments, for interest in soldier-etchers' war commentaries surged during the pacifist movements of the 1930s.

The etchings of Kerr Eby became a significant part of the pacifist movement. Eby, who had enlisted in 1917 and was an engineer attached to an artillery regiment, experienced firsthand the horrors of the war in the battles of Château-Thierry and Saint-Mihiel. *September 13, 1918, St. Mihiel (The Great Black Cloud)* (see Helsinger, Figure 22) powerfully portrays the immense cloud that hung for several days above the troops. A German veteran, upon seeing Eby's drawings on this subject, was said to have remarked that the cloud appeared to troops on his side as deep red and was thus named "The Cloud of Blood."[10]

With the threat of a second world war looming large, Eby published *War* (1936), a collection of etchings, drawings, drypoints, and lithographs drawn from his own experiences. In it, he wrote that he hoped his art would be of some service in the fight against war, although he was ambivalent about his status as a "pacifist":

> I have been accused of being a pacifist. Just what constitutes a pacifist is rather vague in my mind. I am not a pacifist if it means not to see the necessity of an army and navy in this world as it is and not to thank God for them. If it is to keep turning the other cheek like the pivoted head of an owl, I have not reached that state of Christian forbearance but I most certainly am a pacifist if being one is to believe that there can be and are other

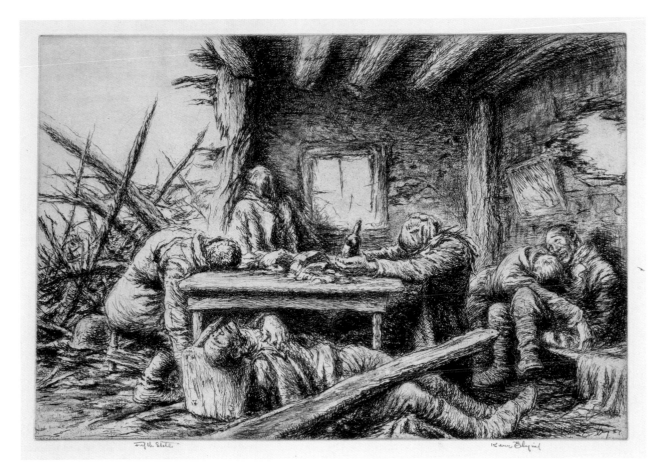

FIGURE 77
Kerr Eby
The Last Supper, 1937
Etching
Cat. 13

ways of settling differences between Christian nations than murdering youngsters—and that lawful, not to say sanctified, wholesale slaughter is simply slobbering imbecility.[11]

The book contains a drawing of *The Last Supper*, which was made into an etching the following year (Figure 77). Eby rewrites the traditional scene of Christ's Last Supper to condemn "the incredible folly of supposedly Christian nations" who betray their sons by creating wars in which they must forfeit their lives.[12] Eby calls our attention to the sacrifice of each of these innocents led to the "slaughter" and questions its necessity through his refusal of any "dulce et decorum est" visual rhetoric.[13] The eucharistic elements—the bread and the wine on the table—are not sanctified but instead highly ironized by the grotesque portrayal of the broken flesh and spilled blood of these men.

Eby later attempted to enlist in World War II but was denied because of his age. He instead served as a combat artist for Abbott Laboratories (a maker of plasma) and was embedded with the Marines at Tarawa and Bougainville in the Pacific. He made many charcoal drawings of his experiences, which are now housed in the Naval Historical Center in Washington, D.C.; he did not live to turn them into etchings because of the fatal tropical disease he contracted during the weeks he spent in the swampy foxholes of the South Pacific.[14]

In *War*, Eby wrote that the images in his book were "not imaginary" because they were "made from the indelible impressions of war."[15] "Impressions," with its reference to the printmaker's art, amounts to a fitting metaphor for the caustic forces of war forever etched on the minds of the soldiers of Eby's generation.

NOTES

1. Kenneth M. Guichard, *British Etchers, 1850–1940* (London: R. Garton, 1977), 46.

2. Ibid., 24.

3. "U.S. Etching v. British," *Time*, February 10, 1930, http://www.time.com/time/printout/0,8816,738617,00.html (accessed May 5, 2008).

4. Ibid.

5. Information on the involvement of Bone (and the other etchers discussed in this paragraph) in the world wars comes from Gladys Engel Lang and Kurt Lang, *Etched in Memory: The Building and Survival of Artistic Reputation* (Chapel Hill: University of North Carolina Press, 1990), 250–68.

6. Quoted in Ernest S. Lumsden, *The Art of Etching* (London: Seeley, Service, 1925), 354.

7. *Burlington Magazine* 40, no. 230 (May 1922): 247.

8. Lumsden, *The Art of Etching*, 322.

9. This was particularly true for American war etchers, who did not attain the kind of fame that British war artists did. Lang and Lang explain that "[n]ot only had America been touched less directly by the slaughter, but also the novelty had worn off by the time their work appeared. Examples of British art had preceded them across the Atlantic and, with the war over, most people wanted to get back to 'normalcy'" (*Etched in Memory*, 258).

10. Kerr Eby, *War* (1936; reprint, New York: Garland Publishing, 1971), 7; Dorothy Keppel, "Kerr Eby," *Print Collector's Quarterly* 26 (February 1939): 91.

11. Kerr Eby, *War*, "Introduction," n.p.

12. Ibid.

13. In his 1917 poem, soldier-poet Wilfred Owen exposed "The old Lie: / *Dulce et decorum est / Pro patria mori*" ("It is sweet and fitting to die for one's country").

14. Lang and Lang, *Etched in Memory*, 260–61; The Naval Historical Center, "Kerr Eby (1889–1946)," Department of the Navy, http://www.history.navy.mil/ac/artist/e/eby/eby1.htm (accessed May 5, 2008).

15. Eby, *War*, "Introduction."

All works are in the Smart Museum of Art unless otherwise noted. Height precedes width in all measurements unless otherwise indicated.

1 John Taylor Arms
 American, 1887–1953
 Oviedo, the Holy, 1937
 Etching on laid paper
 Fletcher 306, third state
 12 ¼ x 4 ⅜ in. (31.1 x 11.1 cm), plate; 16 ⅜ x 7 ⅝ in.
 (41.6 x 19.4 cm), sheet
 Gift of Brenda F. and Joseph V. Smith
 2007.24.1
 Figure 9

2 John Taylor Arms
 American, 1887–1953
 The Valley of the Savery, Wyoming, 1934
 Etching on laid paper
 Fletcher 276, third state
 7 ⅞ x 14 ³⁄₁₆ in. (20 x 36 cm), plate; 11 ⁷⁄₁₆ x 18 in.
 (29 x 45.7 cm), sheet
 Gift of Brenda F. and Joseph V. Smith
 2007.26
 Figure 10

3 Robert Sargent Austin
 British (English), 1895–1973
 The Bell #1, 1926
 Engraving on laid paper
 Dodgson 67, second state
 5 ⅜ x 4 ³⁄₁₆ in. (13.7 x 10.6 cm), plate; 10 ½ x 8 in.
 (26.7 x 20.3 cm), sheet
 Gift of Brenda F. and Joseph V. Smith
 2007.30
 Figure 74

4 Robert Sargent Austin
 British (English), 1895–1973
 Man with a Crucifix, 1924
 Etching on laid paper
 Dodgson 45, fifth state
 5 ⅜ x 4 ½ in. (13.7 x 11.4 cm), plate; 8 ½ x 7 ⅞ in.
 (21.6 x 20 cm), sheet
 Gift of Brenda F. and Joseph V. Smith
 2007.28
 Figure 63

5 Robert Sargent Austin
 British (English), 1895–1973
 The Mendicants, 1924
 Etching on laid paper
 Dodgson 50
 4 ½ x 3 ¾ in. (11.4 x 9.5 cm), plate; 9 ⁷⁄₁₆ x 7 ⅝ in.
 (24 x 19.4 cm), sheet
 Gift of Brenda F. and Joseph V. Smith
 2007.29
 Figure 73

6 Muirhead Bone
 British (Scottish), 1876–1953
 Railway Sheds, Marseilles, 1937
 Etching and drypoint on wove paper
 9 ⁵⁄₁₆ x 12 ½ in. (23.7 x 31.8 cm), plate; 13 ½ x 17 in.
 (34.3 x 43.2 cm), sheet
 Gift of Brenda F. and Joseph V. Smith
 2007.36
 Figure 11

7 Félix Bracquemond
 French, 1833–1914
 The Upper Part of a Door (Le haut d'un battant de porte),
 1865
 Etching on wove paper
 Beraldi 110, fifth state; Bouillon Ac 1, eighth state
 12 x 15 ¾ in. (30.5 x 40 cm), plate; 13 ³⁄₁₆ x 17 in.
 (33.5 x 43.2 cm), sheet
 University Transfer from Max Epstein Archive, Gift of the
 Carnegie Corporation, 1927
 1967.116.71
 Figure 49

8 Hablot Knight Browne
 British (English), 1815–1882
 Tom-All-Alone's, from *Bleak House*, by Charles Dickens
 (London: Bradbury and Evans, 1853)
 Printed book
 Length: 7 ⅞ in. (20 cm)
 University of Chicago Library, Special Collections
 Research Center, Helen and Ruth Regenstein Collection
 of Rare Books
 PR4555.A1 1853 Rare
 Figure 21

9 Félix-Hilaire Buhot
French, 1847–1898
A Landing in England (Un débarquement en Angleterre),
1879
Etching, drypoint, aquatint, and roulette on laid paper
Bourcard 130, fifth state
12¾ x 7 in. (32.4 x 17.8 cm), plate; 15 x 9⅛ in.
(38.1 x 23.2 cm), sheet
Gift of Brenda F. and Joseph V. Smith
2003.27
Figure 52

10 David Young Cameron
British (Scottish), 1865–1945
Thermae of Caracalla, 1923
Etching on laid paper
Rinder 470, third state
10¾ x 16³⁄₁₆ in. (27.3 x 41.1 cm), plate; 12⅜ x 18⅛ in.
(31.4 x 46 cm), sheet
Gift of Brenda F. and Joseph V. Smith
2007.45
Figure 60

11 Charles-François Daubigny
French, 1817–1878
Full Moon at Valmondois (Clair de lune à Valmondois), 1877
Etching on laid paper
Delteil 127, fourth state
6⅝ x 9¼ in. (16.8 x 23.5 cm), plate; 7⅛ x 10¼ in.
(18.1 x 26 cm), sheet
Gift of Brenda F. and Joseph V. Smith
2004.137
Figure 42

12 Richard Earlom
British (English), 1743–1822
(after Claude Lorrain, French, active in Italy, 1604–1682)
A Landscape, 1803, from the *Liber Veritatis*
(London: Boydell and Co., 1819), Vol. III, Pl. 23
Etching and mezzotint in printed book
Length: 17⅜ in. (44 cm)
University of Chicago Library, Special Collections
Research Center
fND553.G3A3, vol. 3
Figure 18

13 Kerr Eby
American, 1889/90–1946
The Last Supper, 1937
Etching on laid paper
Giardina 188, second state
9⁹⁄₁₆ x 14 in. (24.3 x 35.6 cm), plate; 12⅝ x 16½ in.
(32.1 x 42 cm), sheet
Gift of Brenda F. and Joseph V. Smith
2007.57.3
Figure 77

14 Kerr Eby
American, 1889/90–1946
September 13, 1918, St. Mihiel (The Great Black Cloud), 1934
Etching and aquatint on wove paper
Giardina 182, fourth state
10¼ x 15¹³⁄₁₆ in. (26 x 38.5 cm), plate; 13⅜ x 18⅝ in.
(34 x 47.3 cm), sheet
Gift of Brenda F. and Joseph V. Smith
2007.54
Figure 22

15 Frederick Landseer Maur Griggs
British (English), 1876–1938
The Ford, 1915
Etching on laid paper
Comstock 9, third state
5¾ x 9⅜ in. (14.6 x 23.9 cm), plate; 8¾ x 11⅜ in.
(22.2 x 28.9 cm), sheet
Gift of Brenda F. and Joseph V. Smith
2007.60
Figure 61

16 Frederick Landseer Maur Griggs
British (English), 1876–1938
Memory of Clavering, 1934
Etching on laid paper
Comstock 51, fourth state
5⅞ x 9⁷⁄₁₆ in. (14.9 x 24 cm), plate; 6⁹⁄₁₆ x 9½ in.
(16.7 x 24.1 cm), sheet
Gift of Brenda F. and Joseph V. Smith
2007.61
Figure 62

17 Sir Francis Seymour Haden
British (English), 1818–1910
The Breaking Up of the Agamemnon, 1870
Etching on laid paper
Schneiderman 133
7⅝ x 16⅛ in. (19.4 x 41 cm), plate; 8⅞ x 17⁷⁄₁₆ in.
(22.5 x 44.3 cm), sheet
Gift of the Estate of Philene Frevert
1984.114
Figure 5

18 Sir Francis Seymour Haden
British (English), 1818–1910
Hands Etching—O Laborum, 1865
Etching and drypoint on laid paper
Schneiderman 84, sixth state
5½ x 8⅜ in. (14 x 21.3 cm), plate; 7½ x 10¼ in.
(19.1 x 26 cm), sheet
University Transfer from Max Epstein Archive, Carrie B.
Neely Bequest, 1940
1967.116.16
Figure 34

19 Julius Komjati
Hungarian, 1894–1958
Morning, 1919
Etching on wove paper
11 ¹⁵⁄₁₆ x 16 ³⁄₁₆ in. (30.3 x 41.1 cm), plate; 14 ¹⁵⁄₁₆ x 19 in.
(38 x 48.3 cm), sheet
Gift of Brenda F. and Joseph V. Smith
2007.66
Figure 71

20 Armin Landeck
American, 1905–1984
East River Drive, 1941
Etching on wove paper
Kraeft 82
9 ¾ x 12 ¹³⁄₁₆ in. (24.8 x 32.5 cm), plate; 14 ¹⁵⁄₁₆ x 21 in.
(37.9 x 53.3 cm), sheet
Gift of Brenda F. and Joseph V. Smith
2004.143
Figure 23

21 Alphonse Legros
French, active in Britain, 1837–1911
*A Tramp Advancing along a Lane (Un vagabond passant
dans une ruelle)*, undated
Etching on laid paper
Legros 265
5 ¹⁵⁄₁₆ x 10 ¹³⁄₁₆ in. (15.1 x 27.5 cm), plate; 10 ⅝ x 14 ¾ in.
(27 x 37.5 cm), sheet
Gift of Dr. and Mrs. Meyer S. Gunther
1995.91
Figure 55

22 Clare Leighton
American, born in England, 1898–1989
New York Breadline, 1932
Wood engraving on wove paper
11 ⅞ x 7 ¹⁵⁄₁₆ in. (30.2 x 20.2 cm), block; 14 ⅝ x 10 ⅛ in.
(37.2 x 25.7 cm), sheet
Gift of Brenda F. and Joseph V. Smith
2007.108
Figure 68

23 Martin Lewis
American, 1881–1962
East Side Night, Williamsburg Bridge, 1928
Etching on laid paper
9 ¹³⁄₁₆ x 12 ⅞ in. (24.9 x 32.7 cm), plate; 14 ⅞ x 20 ⅞ in.
(37.8 x 53 cm), sheet
University Transfer from Max Epstein Archive, Carrie B.
Neely Bequest, 1940
1967.116.264
Figure 25

24 Martin Lewis
American, 1881–1962
The Return, 1925
Drypoint on wove paper
7 ⅞ x 9 ¹⁵⁄₁₆ in. (20 x 25.2 cm), plate; 12 ³⁄₁₆ x 16 in.
(31 x 40.6 cm), sheet
Gift of Brenda F. and Joseph V. Smith
2007.68
Figure 24

25 David Lucas
British (English), 1802–1881
(after John Constable, British [English], 1776–1837)
Hampstead Heath, Stormy Noon, Sand Diggers, 1831
Mezzotint on chine appliqué
Shirley 23
5 ⅝ x 7 ⁹⁄₁₆ in. (14.3 x 19.2 cm), sheet, trimmed almost to
image
Gift of Brenda F. and Joseph V. Smith
2007.49
Figure 19

26 Ernest Stephen Lumsden
British (English), 1883–1948
Jodhpur, probably c. 1928–38
Etching on laid paper
10 ¾ x 14 ¹⁵⁄₁₆ in. (27.3 x 37.9 cm), plate; 12 ³⁄₁₆ x 17 ¹¹⁄₁₆ in.
(31 x 45 cm), sheet
Gift of Brenda F. and Joseph V. Smith
2007.70
Figure 12

27 James McBey
British (Scottish), 1883–1959
The Bridge by Night, 1925
Drypoint on laid paper
Hardie 232
9 ⁷⁄₁₆ x 5 ⁵⁄₁₆ in. (24 x 13.5 cm), plate; 12 ¾ x 8 ¼ in.
(32.4 x 21 cm), sheet
Gift of Brenda F. and Joseph V. Smith
2007.72
Figure 7

28 James McBey
British (Scottish), 1883–1959
Sea and Rain, 1914
Etching on laid paper
Hardie 153
6 ⁵⁄₁₆ x 8 ⅜ in. (16 x 21.3 cm), plate; 9 ⅞ x 11 ⅛ in.
(25.1 x 28.3 cm), sheet
Gift of Brenda F. and Joseph V. Smith
2007.71
Figure 76

29 Charles Meryon
French, 1821–1868
Chevrier's Cold Bath (Bain-froid Chevrier), 1864
Etching on wove paper
Delteil 44, sixth state; Schneiderman 93, fifth state
5 ³/₁₆ x 5 ⅝ in. (13.2 x 14.3 cm), plate; 8 ¹/₁₆ x 12 in.
(20.5 x 30.5 cm), sheet
Gift of Brenda F. and Joseph V. Smith
2003.29
Figure 47

30 Charles Meryon
French, 1821–1868
Turret, Rue de l'École de Médecine, 22, Paris (Tourelle, rue de l'École de Médecine, 22, Paris), 1861
Etching on laid paper
Delteil 41, ninth state; Schneiderman 72, thirteenth state
8 ¼ x 5 ¼ in. (21 x 13.3 cm), plate; 11 ⁷/₁₆ x 8 ⅞ in.
(29 x 22.5 cm), sheet
Gift of Brenda F. and Joseph V. Smith
2003.40
Figure 69

31 Charles Meryon
French, 1821–1868
The Vampire (Le stryge), 1853
Etching on pale green laid paper
Delteil 23, sixth state; Schneiderman 27, seventh state
6 ¾ x 5 ¹/₁₆ in. (17.2 x 12.9 cm), plate; 15 ¼ x 11 ⅜ in.
(38.7 x 28.9 cm), sheet
Gift of Brenda F. and Joseph V. Smith
2003.39
Figure 54

32 Jean-François Millet
French, 1814–1875
Peasant Returning from the Manure Heap (Le paysan rentrant du fumier), 1855
Etching on wove paper
Delteil 11, fourth state
6 ½ x 5 ¼ in. (16.5 x 13.3 cm), plate; 8 ⁹/₁₆ x 6 ⅞ in.
(21.8 x 17.5 cm), sheet
Gift of Brenda F. and Joseph V. Smith
2004.146
Figure 72

33 Samuel Palmer
British, 1805–1881
Opening the Fold, from *An English Version of the Eclogues of Virgil*
(London: Seeley & Company, 1883)
Etching in printed book
Length: 15 in. (38 cm)
University of Chicago Library, Special Collections
Research Center
fPA6807.B7P3
Figure 14

34 Ernest David Roth
American, born in Germany, 1879–1964
Theater Marcellus, Rome, 1914
Etching on laid paper
11 ⁵/₁₆ x 13 ⅛ in. (28.7 x 33.3 cm), plate; 13 ½ x 16 in.
(34.3 x 40.6 cm), sheet
Gift of Brenda F. and Joseph V. Smith
2007.80
Figure 8

35 Frank Short
British (English), 1857–1945
A Span of the Battersea Bridge, 1899
Aquatint on wove paper
Hardie 155
7 ⁷/₁₆ x 11 ⅝ in. (18.9 x 29.5 cm), plate; 11 ¾ x 16 ½ in.
(29.9 x 41.9 cm), sheet
Gift of Brenda F. and Joseph V. Smith
2007.85
Figure 20

36 Frank Short
British (English), 1857–1945
(after Joseph Mallord William Turner, British [English],
1775–1851)
Ben Arthur, c. 1888
Mezzotint on wove paper
Hardie 13, second state
7 ¹/₁₆ x 10 ⅜ in. (17.9 x 26.4 cm), plate; 10 ⁵/₁₆ x 13 ⅜ in.
(26.2 x 34 cm), sheet
Gift of Brenda F. and Joseph V. Smith
2007.84
Figure 15

37 Percy John Delf Smith
British (English), 1882–1948
Death Awed, c. 1918–19
Etching on laid paper
8 x 10 in. (20.3 x 25.4 cm), plate; 10 ¾ x 12 ⅝ in.
(27.3 x 32.1 cm), sheet
Gift of Brenda F. and Joseph V. Smith
2003.30
Figure 13

38 William Strang
British (Scottish), 1859–1921
The Mother, 1884
Etching on laid paper
W. Strang 58, D. Strang 79, fourth state
8 ¾ x 6 ⅞ in. (22.2 x 17.5 cm), plate; 13 ⅝ x 9 ⁷/₁₆ in.
(34.6 x 24 cm), sheet
Gift of Brenda F. and Joseph V. Smith
2007.89
Figure 56

39 Joseph Webb
British (English), 1908–1962
The Prison, 1930
Etching on laid paper
6 ¹⁵⁄₁₆ x 11 ⅞ in. (17.6 x 30.2 cm), plate; 8 ³⁄₁₆ x 12 ⅞ in.
(20.8 x 32.7 cm), sheet
Gift of Brenda F. and Joseph V. Smith
2007.94
Figure 70

40 Levon West
American, 1900–1968
Blizzard Coming, 1931
Etching and drypoint on laid paper
8 ⅝ x 14 ¹¹⁄₁₆ in. (22 x 37.3 cm), plate; 11 ½ x 17 ⅝ in.
(29.2 x 44.8 cm), sheet
Gift of Brenda F. and Joseph V. Smith
2007.95
Figure 75

41 James Abbott McNeill Whistler
American, 1834–1903
Billingsgate, 1859
Etching on laid paper
Kennedy 47, seventh state
5 ⅞ x 8 ⅞ in. (14.9 x 22.5 cm), plate; 8 ⅝ x 12 in.
(22 x 30.5 cm), sheet
Gift of Brenda F. and Joseph V. Smith
2001.109
Figure 2

42 James Abbott McNeill Whistler
American, 1834–1903
Black Lion Wharf, 1859
Etching and drypoint on laid paper
Kennedy 42, second state
5 ¹³⁄₁₆ x 8 ¹³⁄₁₆ in. (14.8 x 22.4 cm), plate; 9 x 12 in.
(22.9 x 30.5 cm), sheet
Gift of Brenda F. and Joseph V. Smith
2000.93
Figure 29

43 James Abbott McNeill Whistler
American, 1834–1903
The Lime-burner, 1859
Etching on laid paper
Kennedy 46, first state
9 ⅞ x 6 ⅞ in. (25.1 x 17.5 cm), plate; 12 ⅞ x 8 ⅜ in.
(32.7 x 21.3 cm), sheet
Gift of Brenda F. and Joseph V. Smith
2001.108
Figure 28

44 James Abbott McNeill Whistler
American, 1834–1903
Long Venice, 1879–80
Etching on laid paper
Kennedy 212, fifth state
5 ⅛ x 11 ⅞ in. (13 x 30.2 cm), sheet, trimmed to plate
Gift of Brenda F. and Joseph V. Smith
2000.97
Figures 4 and 31

45 James Abbott McNeill Whistler
American, 1834–1903
Soup for Three Sous (Soupe à trois sous), 1859
Etching and drypoint on laid paper
Kennedy 49
6 x 8 ⅞ in. (15.2 x 22.5 cm), plate; 8 ⅛ x 10 ⁹⁄₁₆ in.
(20.6 x 26.8 cm), sheet
Gift of Brenda F. and Joseph V. Smith
2000.94
Figure 30

BAIN FROID
CHEVRIER

BAIN FROID
CHEVRIER